D0537086

CHRONICLE BOOKS

ON FLOWERS

BY

Kathryn Kleinman and Sara Slavin

PHOTOGRAPHY

Kathryn Kleinman

STYLING

Sara Slavin

TEXT

Linda Peterson

DESIGN

Michael Mabry

FOOD

Amy Nathan

Copyright ©1988 by Kathryn Kleinman and Sara Slavin.
All rights reserved.
No portion of this book may be reproduced in any
form without written permission of the publisher.

Produced by Kathryn Kleinman and Sara Slavin
Art Direction by Kathryn Kleinman and Sara Slavin
Edited by Frankie Wright
Photography assistance by Lisa Osta and Debra Casserly
Authors' production assistance by Michaele Thunen
Food Stylist assistance by Stephanie Greenleigh
Editorial Research and Support by Tami Koenig, Deborah Smith,
Kathryn Hoefs and David Skolnick, Peterson & Dodge
Typography by Stan Kane and Deborah Gomez, On Line Typography
Calligraphy courtesy of Alan Hutchison Publishing Co. Ltd.
Design Production by Piper Murakami, Michael Mabry Design

Library of Congress Cataloging-in-Publication Data

Kleinman, Kathryn.
ON FLOWERS.

1. Photography of plants. 2. Photography, Artistic.
3. Flowers. 4. Kleinman, Kathryn.
I. Slavin, Sara. II. Title.
TR724.K54 1988 799'.34 88-4280
ISBN: 0-87701-557-0 (cloth)

Printed in Japan by Toppan Printing Co., Ltd., Tokyo.

Distributed in Canada by
Raincoast Books
112 East 3rd Avenue
Vancouver, B.C.
V5T1C8

10 9 8 7 6 5 4 3 2 1

Chronicle Books
San Francisco, CA

Table of Contents

Preface

Successful collaboration is a rare and gratifying experience. It relies on collaborators sharing a like purpose, rhythm, temperament, and artistic vision. Surprisingly, we developed these common grounds despite our entirely diverse backgrounds: Kathryn grew up in a large family, pedaling her bike through suburban gardens in Golden Valley, Minnesota. Sara is an only child from New York City, an urbanite who knew the best flower stands in Manhattan. Our paths crossed in San Francisco in 1981, and we began working together as photographer and stylist. ¶ For us, styling and creating photographs is a long and intimate process. In the hours we work together—waiting for the right light, composing the elements and props, scouting locations— we talk. Often that talk has been about flowers. "Do you remember. . ." one of us might start, and the other would say "opening the refrigerator door on Sunday morning to see if Mom had left her corsage from the night before in a cellophane box?" Or "Did you ever. . ." and the other might finish with "make tissue flowers of folded Kleenex?" Over time, our list of recollections grew. We talked of making dandelion chains, sipping honeysuckle and wild columbine, collecting flowers for May baskets. Our shared childhood fascination with flowers became the inspiration and force behind this book. ¶ Early in 1986 we began planning *On Flowers,* our personal vision of photography and flowers. We worked through the seasons, always inspired by flowers as they appeared before us. The flowers and arrangements were chosen from the camera's point of view—the photographs became sketches or studies, as we let the flowers "exist for themselves," let them express, as flowers do so well. ¶ We completed the book in January 1988. Creating it has brought us enormous pleasure. And so, with great joy, we present this book to you and hope that you will find beauty and inspiration in its pages.

Kathryn Kleinman
Sara Slavin

Acknowledgements

As we worked to bring this book together, we found remarkable contributors who shared their vision with us and helped to make this book truly unique. We express our appreciation and gratitude to all of them. ¶ Thank you to Michael Mabry for always exceeding our expectations. An extraordinary designer and illustrator, Michael has brought elegance and imagination to this project. The space he created for our photographs and for the text gave this book the style and identity we'd dreamed about. ¶ Thank you to Linda Peterson for adding the dimension of words, so magnificently and so unselfishly. Her passion for flowers has given this book another highly personal voice, one that complements our photographs perfectly. We are grateful, too, for her research, her creativity, and an endless patience. ¶ Thank you to Michaele Thunen who volunteered her time and talents, which we gratefully accepted. We are sure she was heaven sent. Michaele was at the flower market at 4 a.m. or home sugaring rose petals and creating flower jellies and potpourris, then arriving at the studio with armloads of spectacular and unique flowers to arrange. We cannot imagine completing the book without her help. ¶ Thank you to Amy Nathan for the delicious and gorgeous Taste chapter. For years we have all worked together on food projects, and during that time Amy has introduced us to the wonders of flowers and food. Amy's styling is as delicate as nature itself. ¶ Thank you to David Barich and Chronicle Books for supporting this project and for extending so much freedom to us. Also to Bill LeBlond at Chronicle Books for his support and expertise in finding us a wonderful copy editor, Frankie Wright, whom we also thank for her editing and her knowledge of words and flowers. ¶ Thank you to Lisa Osta and Debra Casserly, our two assistants, who were with us every step of the way. ¶ Thank you to our marvelous flower arrangers: Patrick Powell of Bloomers, Maria Vella and Susan Wolf of Bomarzo, Barbara Belloli and Jean Thompson of Fioridella, Kathleen Dooley and Alexis Lecach of Columbine Design, Eric Cogswell, Mary McCarthy, and Arnelle Kase. Their beautiful arrangements and continued support have contributed so much. ¶ Thank you to Toby Hanson and Claudia Schwartz of Bell'occhio. Their beautiful glazed backgrounds, ribbons, and objects have added so much to our photographs, and their support has been invaluable. ¶ Thank you to Dawn Sutti and Victor Hutchings, two people who brought vision and fantasy to our book. And to Dawn for her subtle and sensitive hand-coloring of our photos. ¶ Thank you to Arnelle Kase, Robert Steffy, Jan Dutton, Eric Cogswell, Claudia Schwartz, Robert Fiegel, Kathryn Kenna, and Koichi Hara for allowing us into their lovely shops and homes. ¶ Thank you to Buddy Rhodes, Atis Zulgis, and Jeffrey Long for wonderful backgrounds. ¶ Thank you to Sue Fisher King, Virginia Breier, paper white ltd., Laurie Ann Campbell, Bloomers, Eric Cogswell, Susan's Store Room, Coup de Chapeau, Silvestri, Palecek, Michaele Thunen, Mary McCarthy, Bomarzo, Luminescence, Barbara Jucick Kleinman, Lillian Moss, Joan Mooney, Laura Lamar and Max Seabaugh, and Claire's Antique Linen for beautiful and special props and vases. ¶ Thank you to our terrific models, Didi Phillips, Sara Wagner, Jessica McCarthy, Peter Schwartz and Ann Imboden. ¶ Thank you to Pamela North of Paradise Farms for supplying us with so many perfect and delicious edible flowers. ¶ Thank you to Piper Murakami and Sarah Keith-Mabry from Michael Mabry's office and Tammy Koenig, Deborah Smith, Kathryn Hoefs, Patty Nasey and David Skolnick from Peterson & Dodge and Stephanie Greenleigh, assistant to Amy Nathan, for their energy, enthusiasm and hard work. ¶ Thank you to Ellie Traugh, Louise Fili, Maureen Burke, Ray Way from L. Piazza Flowers, Jacqueline Jones, Linda Hinrichs, Anne Mette Abildgaard, Christina Seidler, Charlotte Davis, Garden Valley Ranch Roses, Carla Roth Nasaw, Jacobs Farm, and Anita Lusebank at Sunflor for help, encouragement, and support. ¶ And a special thank you to Michael Schwab and Eric Schwab, and Mark Steisel and Sybil Slavin, and Kate Slavin for their love and support.

Eden was a garden.

We don't know very much about what grew there. There was an apple tree,

of course, and those first, negligent gardeners.

But what we can surmise of paradise, of a place unspoiled by human failings,

is that it must have been filled with flowers.

Paradise on earth seems to be a fragile and entirely individualistic thing these days.

Whatever personal vision of paradise you hold, we hope that it is full

of flowers. This book is for people who care about all the pleasures of flowers.

It comes full of surprises—dark vines on a lace pillowcase, tulip bulbs

sustaining life in World War II, the culinary magic of nasturtium petals on pizza,

and the tale of St. Peter's keys to the front gate of heaven turning into cowslips.

It is a book about beauty.

ESSENCE

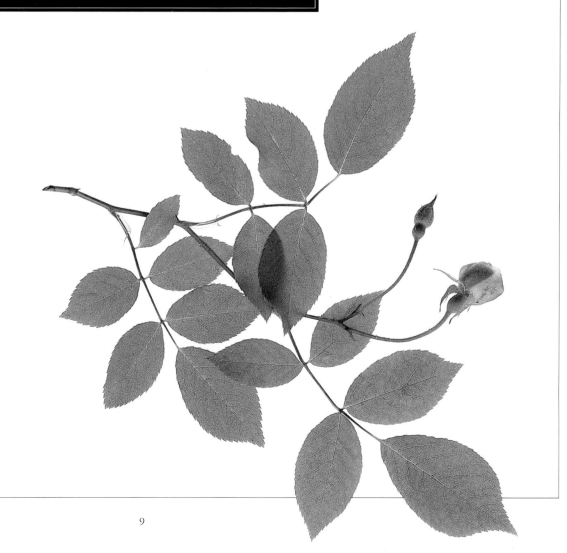

he essence of flowers is that they are both symbols and tangible, sweet-smelling markers for all the occasions, great and small in life. ¶ Children grow up circling rings around the rosie. There is the magic of that first corsage—a few drops of water cling to a single gardenia waiting its turn in a cellophane box in the refrigerator. There are bridal bouquets and boutonnieres, baby carnations for Mother's Day, blooms to celebrate births, to ease grief. ¶ Children may be the most resourceful consumers of flowers. There are honeysuckle cups to sip, blades of grass to whistle, and chinaberries to weave into necklaces. Those who believe in wishes grow up scattering dandelion seeds to the winds. With daisies and buttercups around, who needs a fortune-teller? To the "loves me, loves me not" riddle, add holding a buttercup under a friend's chin to find out who does—or doesn't—like butter. ¶ Flowers on the table mean festivities—Easter lilies and holiday poinsettias, golden mums at Thanksgiving, or a single red rose to say that romance must be in the air. ¶ William Shakespeare knew that when words fail, flowers work. In *A Midsummer*

"I went out in the Spring

To gather the young herbs.

So many petals were falling,

Drifting in confused flight,

That I lost my way."

Ki no Tsurayuki,
*One Hundred
More Poems from
the Japanese*

Night's Dream, Oberon sends Puck, armed only with pansies, to make mischief with Titania. Though we may think of pansies as friendly, even ordinary, Shakespeare knew better. He reminds us the pansy's country name is "love-in-idleness." Says Oberon to Puck, "Fetch me that flower; the herb I show'd thee once:/The juice of it on sleeping eyelids laid/Will make a man or woman madly dote/Upon the next live creature that it sees." ¶ Love-in-idleness works, at least in Puck's naughty hands, and poor Titania falls hopelessly, helplessly in love with a man wearing a donkey's head. ¶ Shakespeare understood what flower lovers suspect— deep in the extravagant colors and shapes and scents of flowers, magic lurks, waiting to be unloosed. ¶ Flowers are almost foolproof, even if you don't believe in Puck's brand of sorcery. Wildflowers in a Mason jar on a table say welcome in a language any guest will understand.

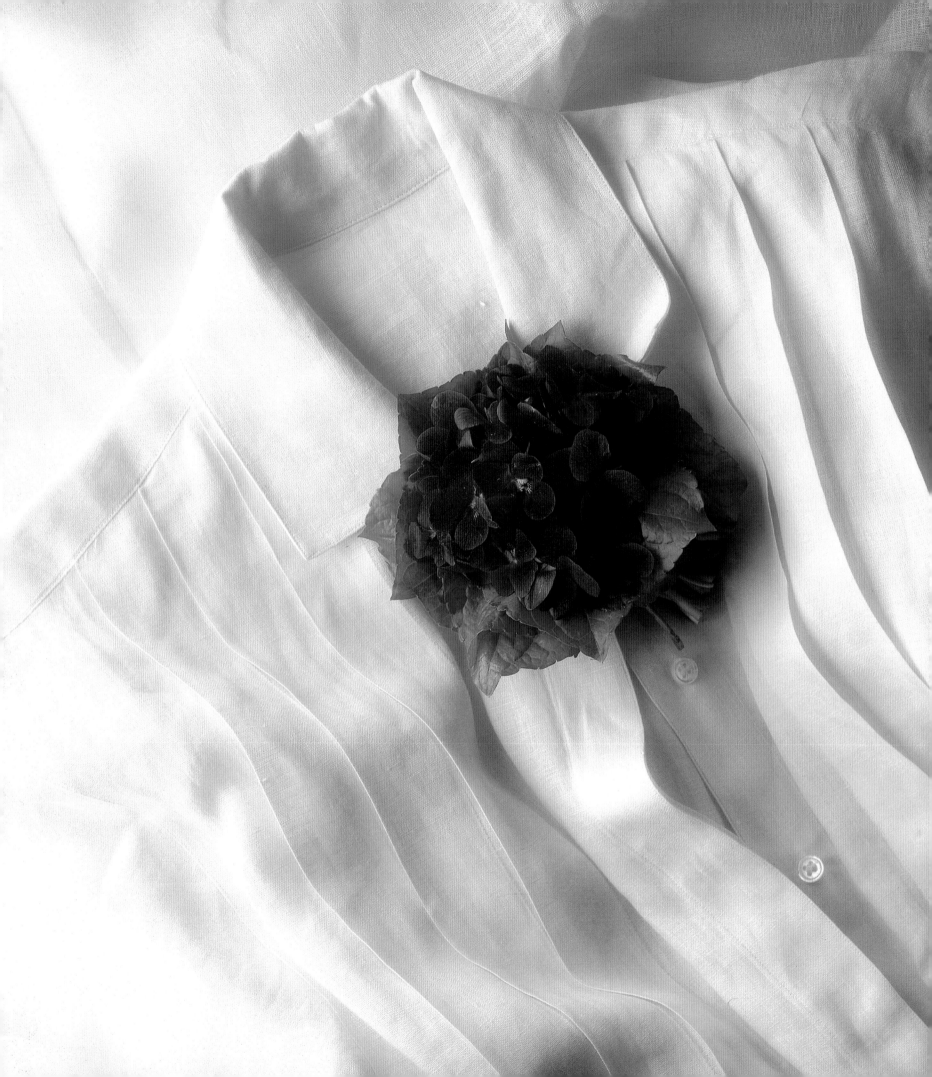

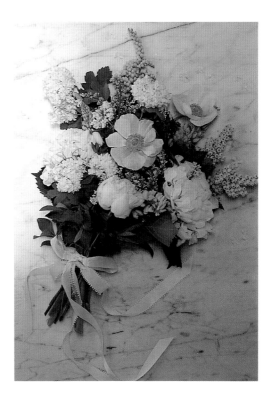

Violets figure in stories from
mythology to George Bernard Shaw.
You may remember that
Eliza Doolittle sold violets before she
became a lady and learned to
pronounce her "h's." But did you know
that Venus herself turned white
violets blue? She did it for spite when her
son Cupid admired the white
blooms for their purity and sweetness.

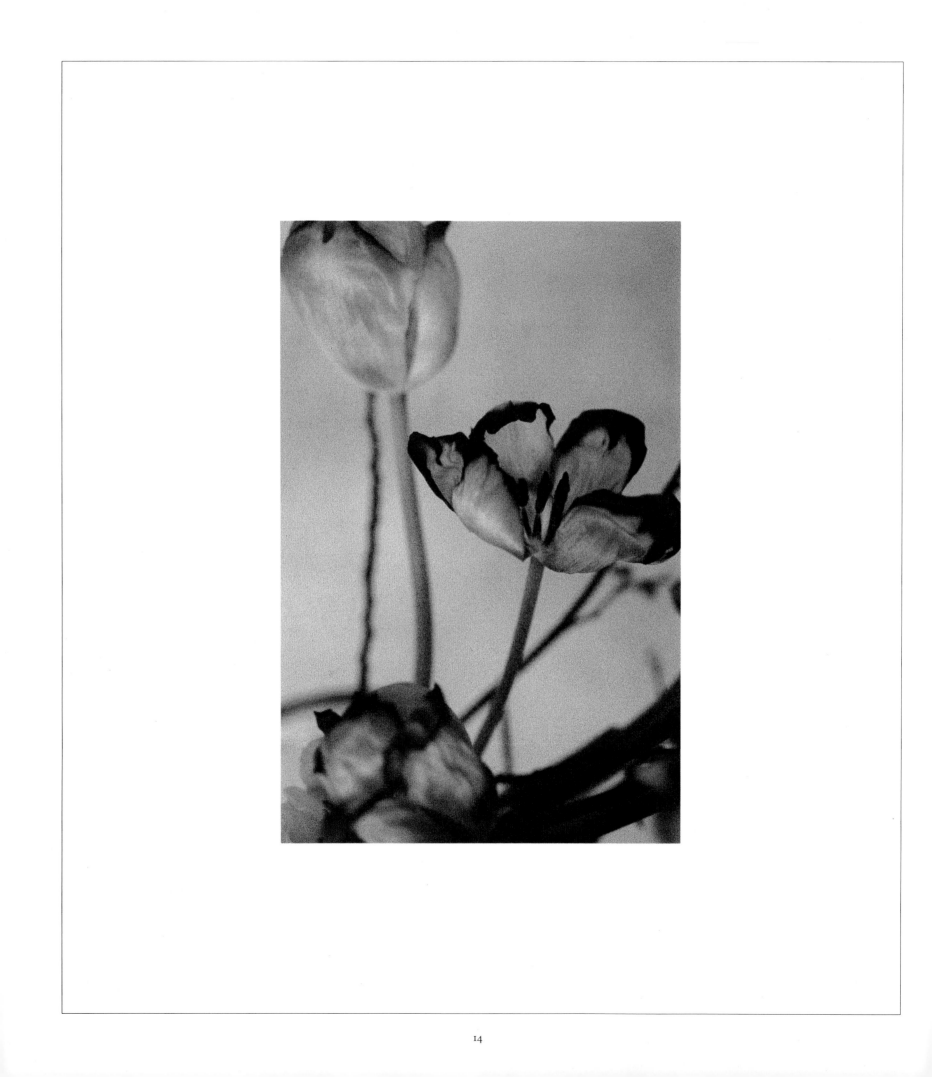

The Confucian Curve

They were in love. Any fool could see that. They bent,

like co-conspirators, over their shopping cart in the Express Lane. Even the cart was

filled with rich, exotic, lovers' food: chicken breasts, lemons, capers, artichokes,

sleek Japanese eggplant. She leaned on the basket, reading aloud to him, "Listen to

this. 'It was the Chinese philosopher Confucius who divided the world into two

parts, halved by a curving line which swung from Pole to Equator. Half the world,

he said, was in darkness, half in light, half in happiness, half in sorrow.'" He

frowned at the basket, "Butter? Do we need butter?" She shook her head. He grinned at

her. "Do that again. Shake your head. I like the light on your hair." She obliged,

and there in the supermarket, in the Express Lane, under the ordinary fluorescent light

and the Double Coupon banners, he bent and kissed her. "Mmmm," he murmured,

"I still think we're forgetting something." ¶ They were, of course. But I caught up with

them out in the parking lot and gave them the bunch of tulips I bought at

the checkout stand. "Dutch tulips," I said in my best gardener's voice, "employ the

Confucian curve. When you're in love, you live in the light."

LUTHER BURBANK

He was "the plant wizard," this New Englander-turned-Californian who developed potatoes, plums, and the Shasta daisy. Luther Burbank was born in 1849 in Massachusetts and died in 1926, after introducing more than 800 new varieties of fruits, vegetables, and flowers to the world. Toward the end of his life, Burbank wrote, "What a joy life is when you have made a close working partnership with Nature."

The fine art of buying a corsage: The creative corsage buyer need not feel his career is over after the senior prom. Consider: Valentine's Day, May Day, Mother's Day, bringing-the-baby-home-from-the-hospital day, for midsummer eve, First Communion or a Bat Mitzvah, all twelve days of Christmas and for the truly romantic—Saturday Night at the Movies. Remember this: No sight is so endearing as that of a gardenia in the refrigerator the morning after.

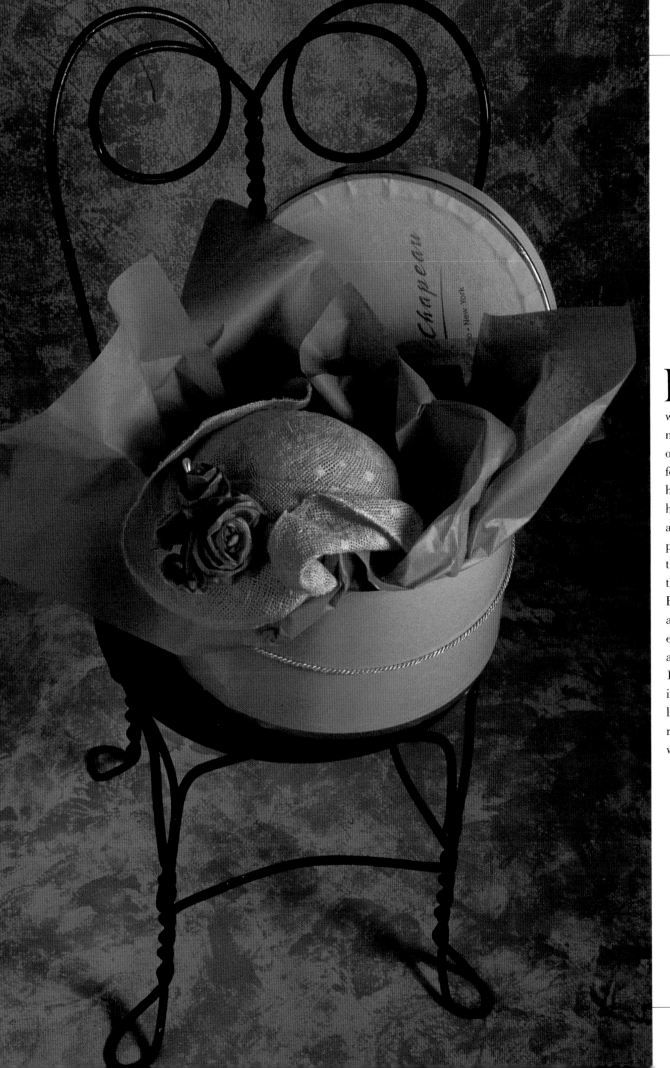

In pursuit of beauty, women have often imitated nature by creating flowers of wax, wire, feathers, chiffon, or velvet to wear on hats and dresses. As fashions have come and gone, artificial flowers have been pinned to the hair, worn on the bosom and decorated the hips and the shoulders. But nothing works so well as the real thing. The Duchess of Devonshire once wore a carnation coronet worth 100 gold sovereigns. And in the 1870s, fine Russian ladies paid 300 to 400 rubles for rare camellias to wear on their ball gowns.

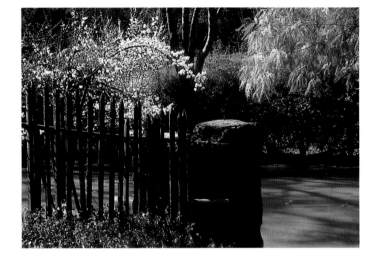

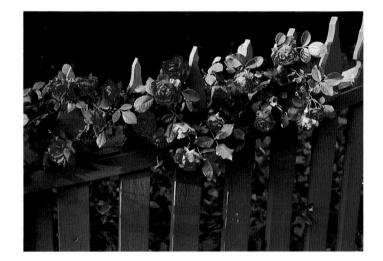

Ashort list of things to discuss on a spring walk with a child: why fallen blossoms look like snow, how many shades of green can be counted along the way, and whether or not it's good manners to run a stick along the fence.

Or you can tell the story of Tom Sawyer and the white picket fence, collect fallen rose petals to take home and make rose petal jelly or perfume, and then explain how the rose was first cultivated in China 5,000 years ago.

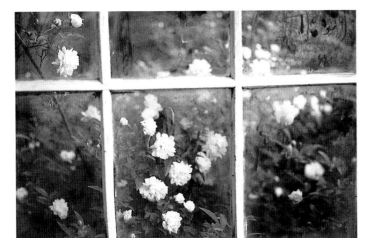

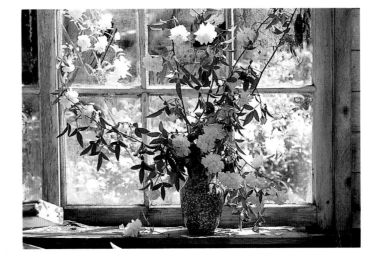

You can peer, politely of course, into the neighbors' windows as you stroll by. You can watch for cats taking sunbaths, other children, delicious-looking kitchens, lovebirds in cages, and vases of spring flowers.

Home again. Take whatever you've gathered, fill a vase or a jar with water (remember to cut the stems under clear water), and display your finds in a window. It's your turn to sit inside and watch the world go by.

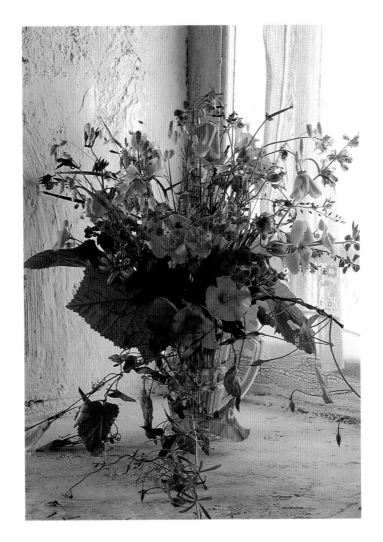

"Yet no, not words, for they
But half can tell love's feeling;
Sweet flowers alone can say
What passion fears revealing."

Thomas Hood,
The Language of Flowers

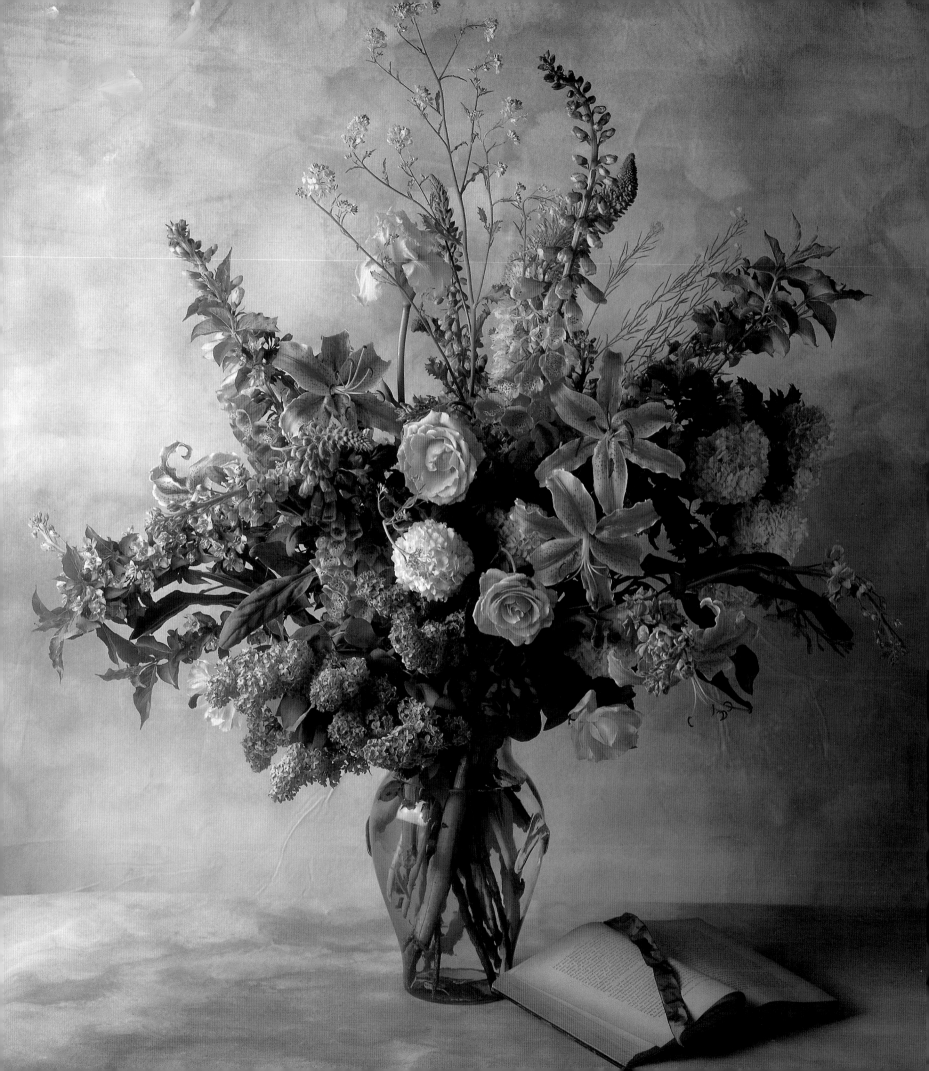

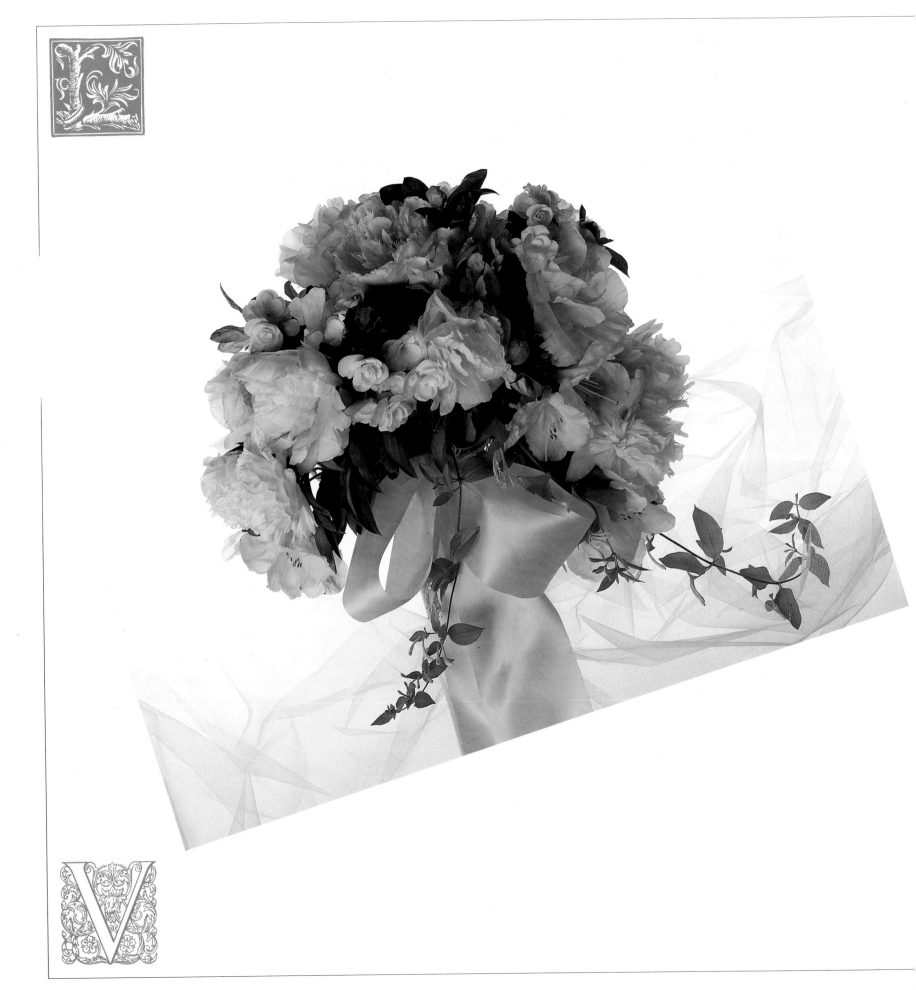

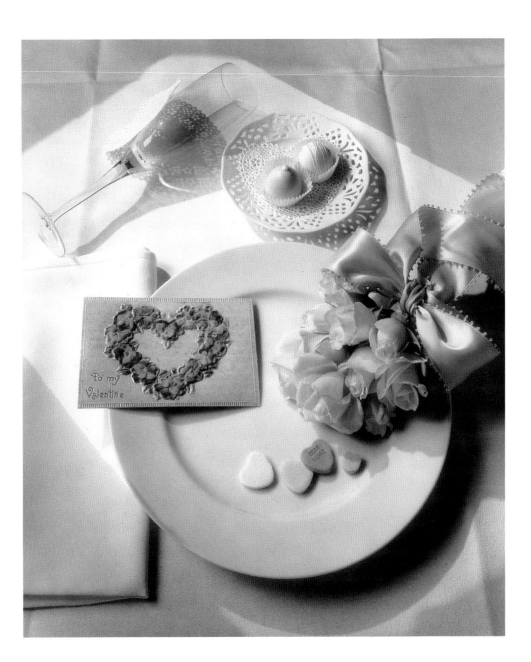

*T*hey seem so fragile, so delicate to be harbingers of good luck. But they are. The Chinese believe peach blossoms bring good fortune during the New Year. The faithful fill their homes with heavily budded branches in hopes that they will bloom on New Year's Day, bringing luck and prosperity to the entire household. The peach bark is said to ward off evil spirits and demons, and the blossoms themselves are symbols of longevity.

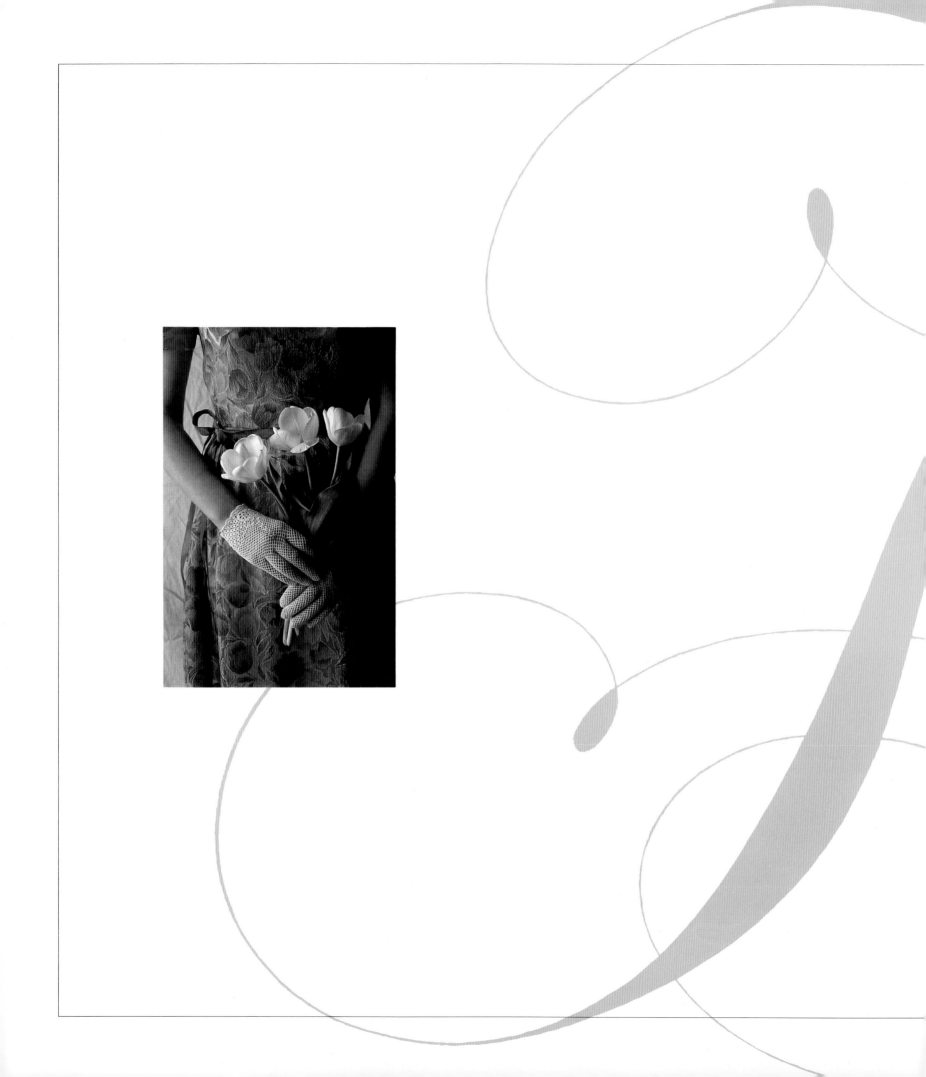

June brings tulips, lilies, roses
Fills the children's hands with posies.
Traditional rhyme

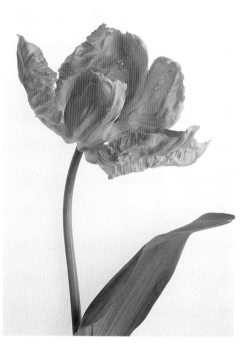

"In joy or sadness, flowers are our constant friends.

We eat, drink, sing, dance, and flirt with them."

Kokuzo Okakura, *The Book of Tea*

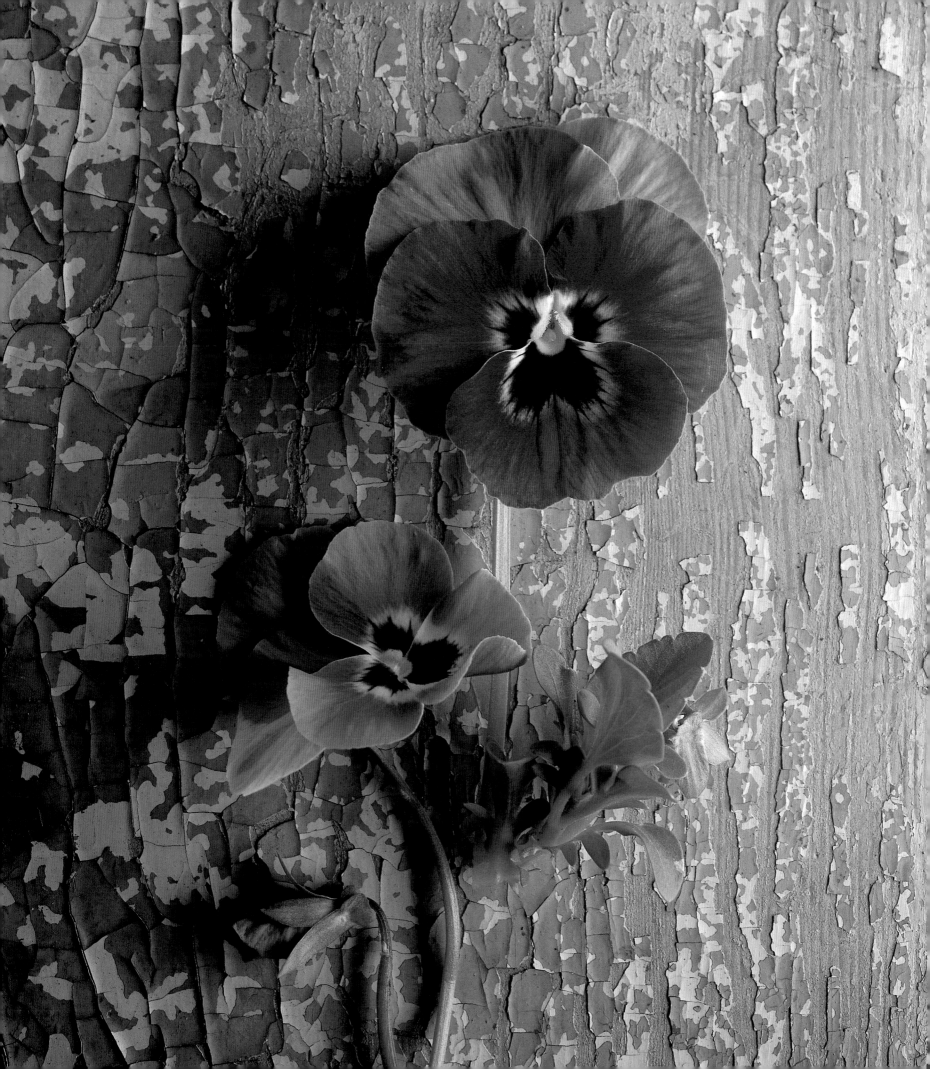

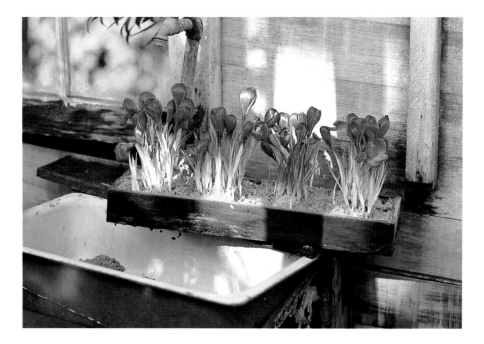

Once upon a time,
according to Christian lore,
pansies were even
more fragrant than violets.
But, the pansy was
distraught that gatherers in
search of its blooms
trampled fields of corn and
vegetables. So the
flower prayed to the Trinity
for its perfume to be
taken away. The prayer must
have been granted,
because today's pansies—or
heart's ease—
have no fragrance at all.

"Flowers are made to seduce the senses:

fragrance, form, colour."

H.D. (Hilda Doolittle)

In the 1890s, the word corsage changed its meaning. Originally a corsage referred to the bodice of a woman's dress, but just before the turn of the century, the word came to mean a small bouquet, natural or constructed, worn as an ornament. To a starry night, a well-tuned orchestra, a polished dance floor, and champagne, add one splendid corsage to guarantee sweet memories.

Wars and roses have a long relationship. The English civil wars, waged from 1455–1485, over the possession of the crown, were called the Wars of the Roses. The name came from the badges of the house of Lancaster (a red rose) and the house of York (a white rose). Battles were long, bloody and bitter, fought over a series of weakened monarchs until Henry VII married Edward IV's daughter Elizabeth in 1486, thereby uniting the two adversarial houses. ¶ But roses have a sweeter connection with war as well. In 1939, as war threatened western Europe, a French hybridist named Francis Meilland discovered something quite special in his nursery, a breathtakingly beautiful rose, growing from a single seed and unlike anything he'd ever grown before. Meilland had no time for further discovery or experimentation so he shipped unnamed and untested cuttings all over the world to friendly growers, hoping at least one cutting would survive. The cuttings destined for Robert Pyle, a grower in Pennsylvania, went out in November 1940 on the last plane from France before Nazis took control of the airports. ¶ Four years later, Pyle wrote to Meilland about a "glorious rose, its pale gold, cream and ivory petals blended to a lightly ruffled edge of delicate carmine." This was the news Meilland had hoped for—a cutting of his splendid rose had survived. ¶ The pale-gold beauty was named "Peace" in a ceremony on the day Berlin fell. Rose lovers from around the world gathered in California to hear the new name and watch as doves were set free in celebration.

GERTRUDE JEKYLL

She was born in London in 1843. But at five, her parents took her to Surrey, a move that brought her in contact with wildflowers, sandy acid soil, and an unspoiled countryside. She grew up with a keen interest in painting and music, an aesthetic she spent her life employing in the design of splendid gardens. Her books, particularly *A Gardener's Testament*, have influenced gardeners around the world. One of her most delightful contributions was *Children and Gardens*, explaining clearly to the youngest reader what part plans, elevations, and even cats, play in a garden.

From "Mary, Mary, Quite Contrary" to "Daffy-down-dilly," some favorite Mother Goose rhymes have chronicled the relationship between children and flowers. The origins of most rhymes are still cloudy, but amateur historians have invented wonderful tales of explanation. "Ring a ring o' Roses," for example, is said, albeit mistakenly, to refer to aromatic nosegays carried during the Great Plague in 1665. But many rhymes are just the music children make to celebrate the pleasures of a game, a sunny day, and a green pasture.

- - - - -

CONTAINED

vase or pitcher. Some cut flowers. Water. Scissors. A deft hand and a critical eye. These elements come together to make very personal magic. ¶ The art of containing flowers is as much an art of subtraction as it is of addition. ¶ Depending on the mood, the season, the room, the garden, and the arranger who is standing puzzled at the sink considering a basketful of flowers and two favorite vases, the "contained" result can be lush or minimalist. There are moments for both. ¶ There is the reductive simplicity of Ikebana, the Japanese school that shudders at the addition of even one superfluous leaf. And there are those extravagant bouquets immortalized by the Dutch and Flemish painters of the seventeenth century. ¶ Anyone who loves to fill rooms with flowers is likely to have collected a lifetime of tips and lore, some true, some not. Certain advice comes up again and again: Visit the garden to cut early in the morning or late in the evening. Recut stems under clear water. Try a dip into peppermint oil for roses, honeysuckle, and dahlias. Better still, try a brief (three seconds!) dip into straight gin for most flowers. You can coax gladiolus to curve

A few stalks of foxglove (digitalis purpurea) in a vase give longer life to the flowers around them. It seems that the same chemistry that stimulates the human heart must encourage cut flowers as well.

a bit if you float them overnight in deep water. There's more, to be collected from books and neighbors. Probably you have secrets of your own. ¶ Here's the best secret: A life spent among flowers is likely to be a long and healthy one. In her book *Green Thoughts,* Eleanor Perenyi chronicles the amazing longevity of gardeners, from botanist Theophrastus who lived to 85 in the second century B.C. to theologian and horticulturist Albertus Magnus, who survived to 87 in the Middle Ages, even amid charges of witchcraft for his experiments with plants. ¶ Gardens aren't always possible. Cities demand expanses of concrete, growing things demand time. But a bunch of violets or daisies can be had from the corner flowerstand or the grocer. Perhaps you're lucky enough to have inherited a rose bowl, a round vase with a small opening, the kind that used to sit on Grandmother's dining table—in the days when there were dining tables, Sunday dinners, and grandmothers who cooked huge, midday meals. ¶ What is contained in a vase, or a bowl or a pitcher or a drinking glass, isn't important. The combination of container, flower, and human imagination is what counts.

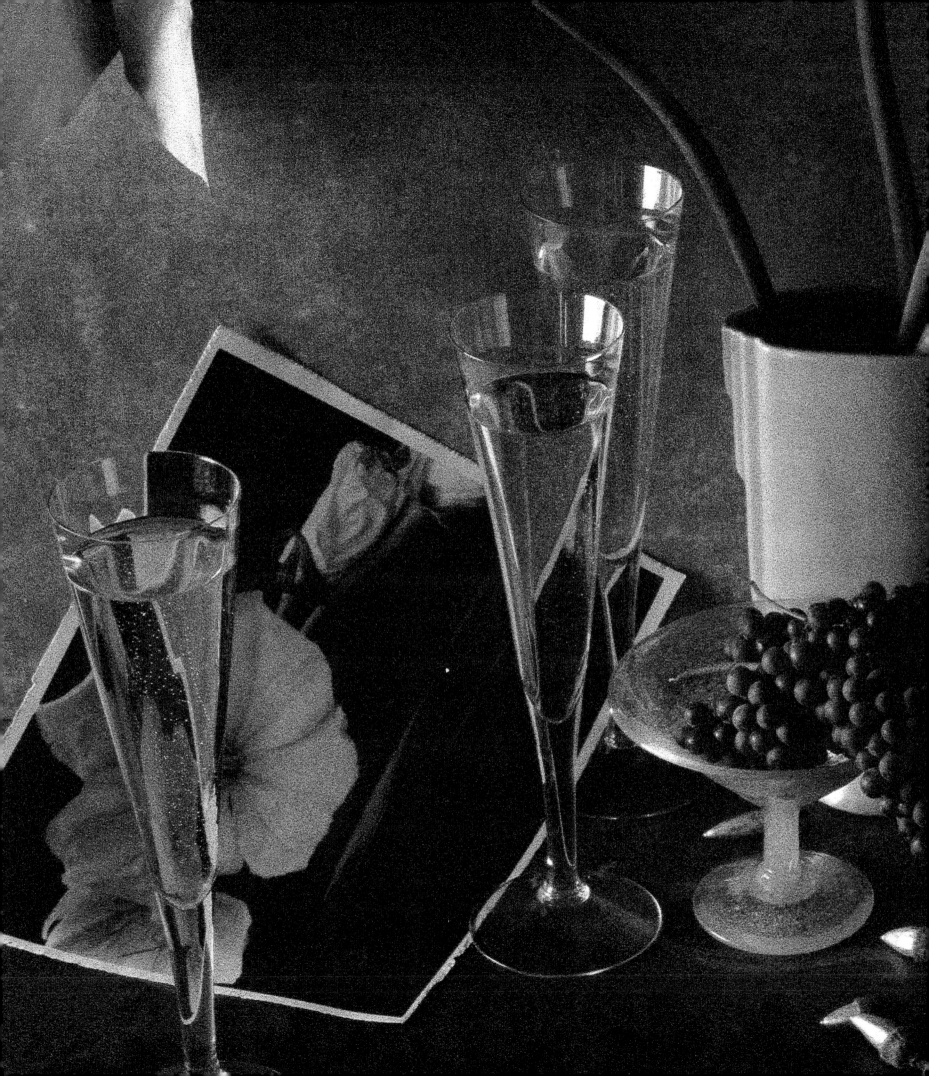

F*lowers,*
food, and celebrations are old
companions. In the late
nineteenth century, creative
hostesses abandoned traditional
centerpieces and scattered
flowers all over the table.
Serious students of table art
sought to recreate indoor
gardens. Some went so far as
to cut holes in their tables
to allow palms or ferns to grow
through and stretch green
fingertips toward the chandelier.

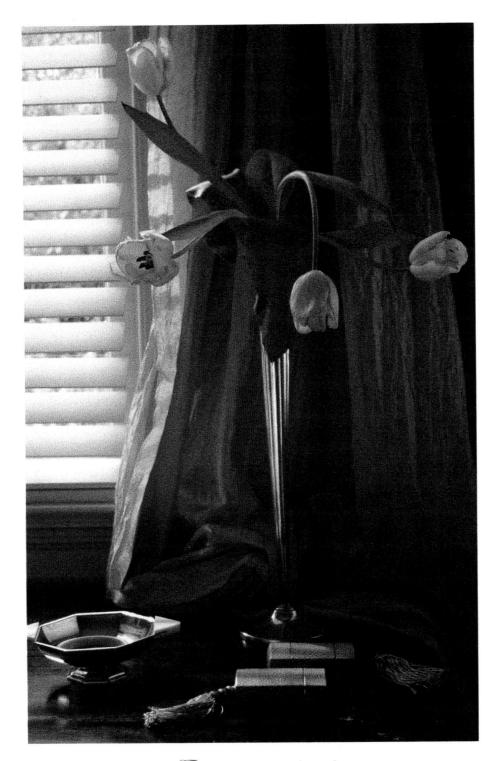

"This is my letter to the world,
That never wrote to me, —
The simple news that Nature told,
With tender majesty."

Emily Dickinson

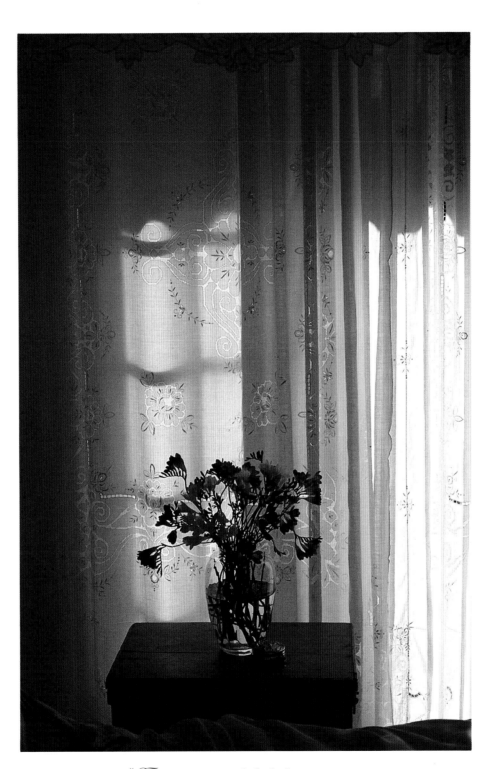

"The appearance of the little sitting-room
as they entered was tranquility
itself....'This is a pleasure,' said he,
in rather a low voice."

Jane Austen, *Emma*

A Room of One's Own

s a matter of dreary historical

accuracy, no literary biographer would ever mistake this

for a Bloomsbury room. In the old photographs you can

see the kind of rooms the Woolfs (Leonard and Virginia)

and the Bells (Vanessa and Clive) favored. They were

cluttered and crowded, filled with overstuffed, flower-

printed furniture. Vanessa's paints and paintings fought

for space with Duncan Grant's. In these rich and

crowded rooms, the Bloomsbury friends ate and argued

and wrote and gossiped and painted and fell in and out

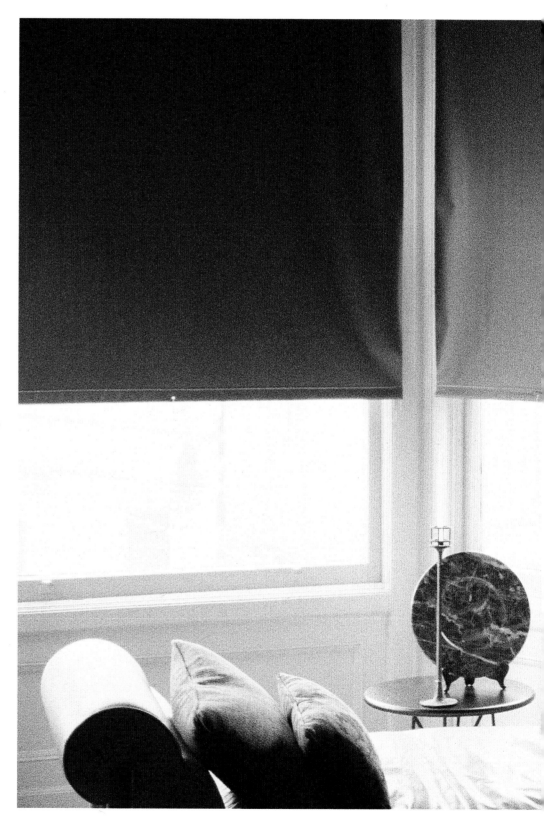

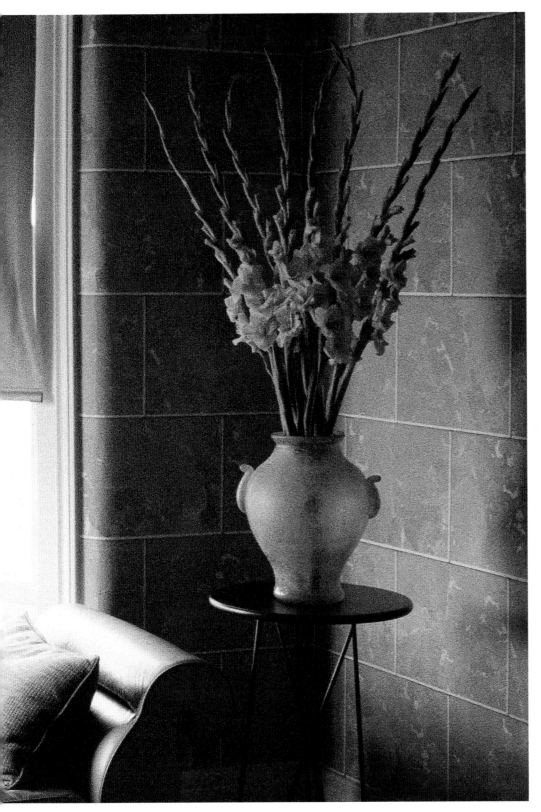

of love and raised children. ¶ But this is the kind of room Virginia Woolf might have imagined for herself: clean, spare, all curves and muted tones. Big windows with shades to draw against the light or the distractions waiting out-of-doors. There would be flowers, of course, but not the big, splashy dahlias Vanessa liked to paint. Instead, one tall cool vase of gladiolus, the Old World iris with sword-shaped leaves. ¶ Virginia Woolf never wrote in such a room. But it's worth imagining she might have. It would have been a room of her own.

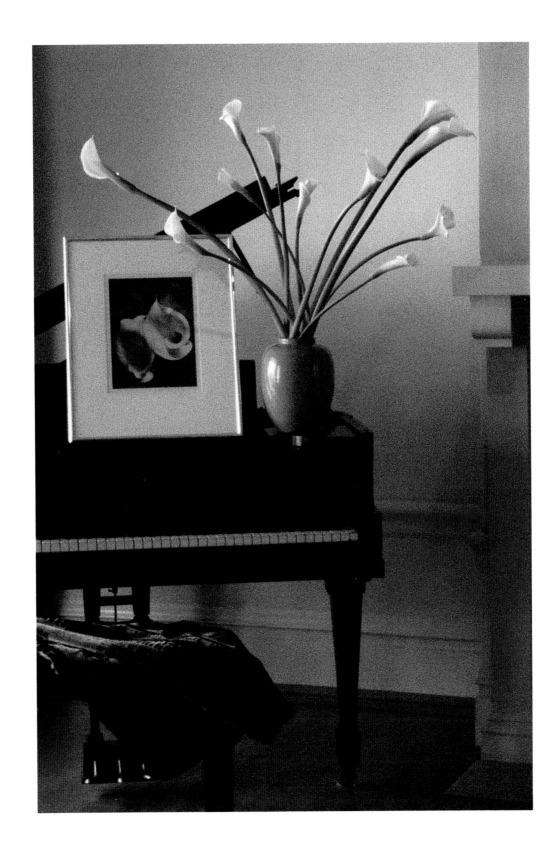

Poveri Fiori: The Music of Flowers

"A true music lover is one who, on hearing a soprano

singing in a bathtub, puts his ear to the keyhole." Scott Beach, writer, radio personal-

ity, and music lover, recorded in his book, *Musicdotes,* a collection of stories,

either real or created. In fact, many true music lovers know their flowers nearly as well

as their notes. Music history—real and created—is full of anecdotes about the

relationship between music and flowers. ¶ There are beloved musical characters with

flowery names: Violetta and Flora in *La Traviata,* Rose Maybud in Gilbert & Sullivan's

Ruddigore and Der Rosenkavalier himself. ¶ There is the flower most Carmens

VITA SACKVILLE-WEST

clench in their teeth, when they tempt the virtuous Don Jose. There is Tchaikovsky's

She lived an entirely original life as wife, lover, mother, poet, journalist, magistrate, novelist, and gardener.

"Waltz of the Flowers," Lecocq's "Fleur de The," and Mozart's *Apollo et Hyacinthus.*

Together with her husband Harold Nicolson, she created Sissinghurst, one of England's most celebrated

¶ Music chronicles the dark, as well as the sweet, side of flowers. Remember that the

gardens. She wrote, "...the place, when I first saw it on a spring day in 1930, caught

Princess de Bouillon sends her rival Adriana poisoned violets in Cilea's opera

instantly at my heart and my imagination. ...I saw what might be made of it. It

Adriana Lecouvreur. Says Adriana as she receives the gift, "Ma perche mai discendere

was Sleeping Beauty's Castle; ...a garden crying

scortesia?" (But why be so rude and unkind?) And then she sings the aria, "Poveri fiori."

out for rescue."

The flower-arranger's art is one of balance. In the classic approach to arranging flowers, you imagine a strong central line running top to bottom from highest point to the base of the container. To look "pleasing" to Western eyes, flowers are arranged so that equal weight appears on either side of the imaginary line.

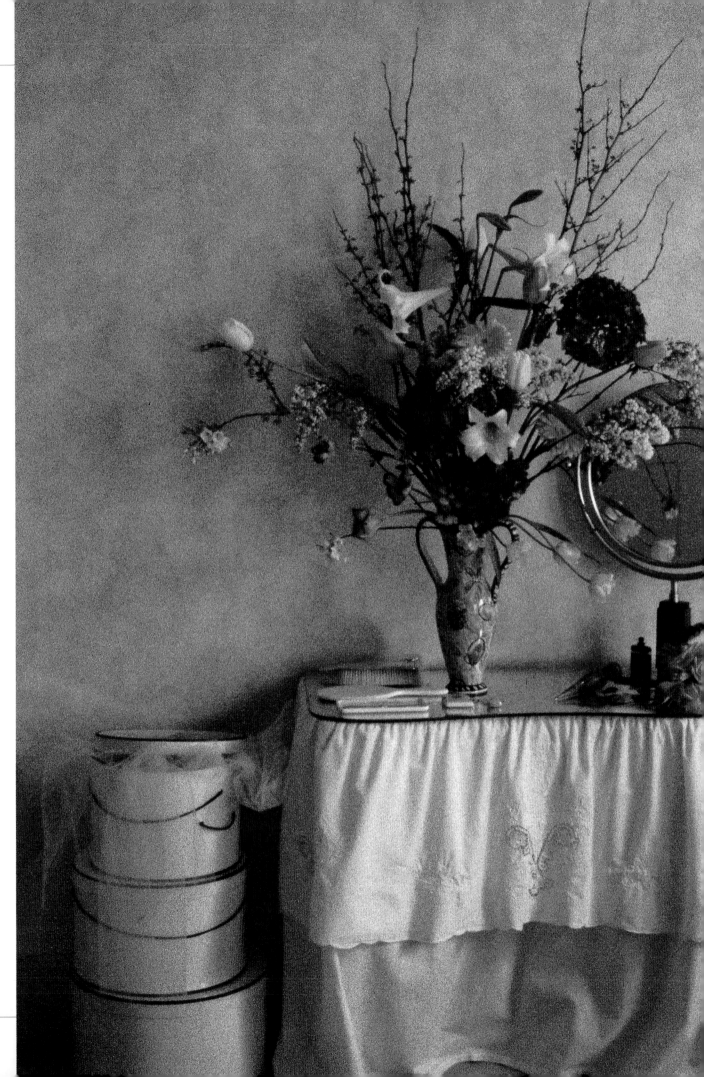

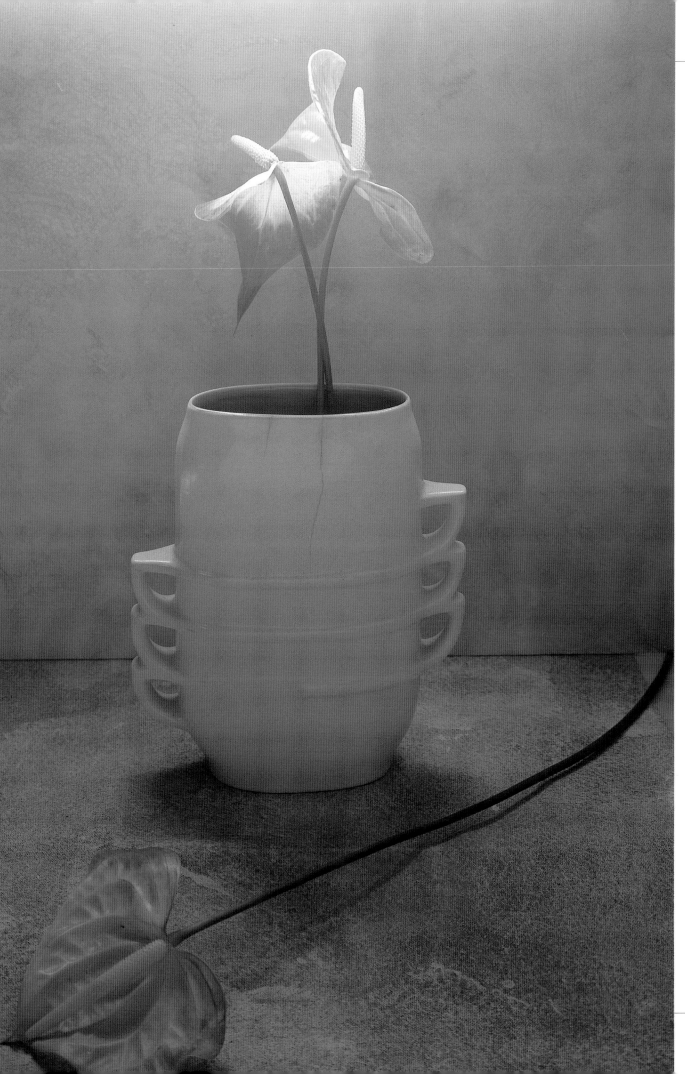

Sometimes balance is a reductive art—isolating one flower and allowing it to speak for itself. This is a surprise to many of us, often favoring the "more is more" approach to containing flowers. One flower, regal and complex, allows the luxury of close examination and appreciation. Less certainly can be more.

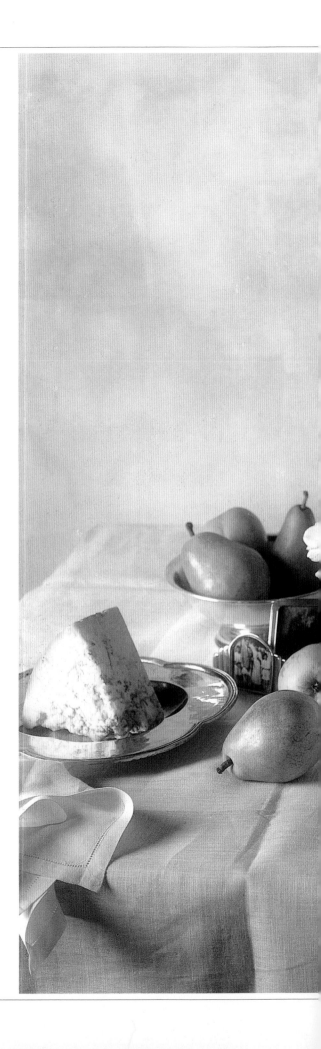

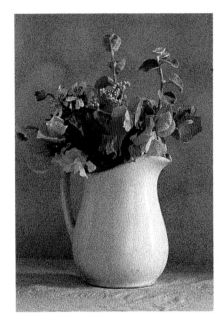

Nurserymen's records suggest that

tulips first came to England from Turkey through Vienna during

the reign of Queen Elizabeth I. They were extravagantly expensive,

even into the nineteenth century, putting them out of reach

of most amateur gardeners. By the end of Queen Victoria's reign,

the price per bulb had become affordable. The wild tulip had

become naturalized as well and came to symbolize hopeless love.

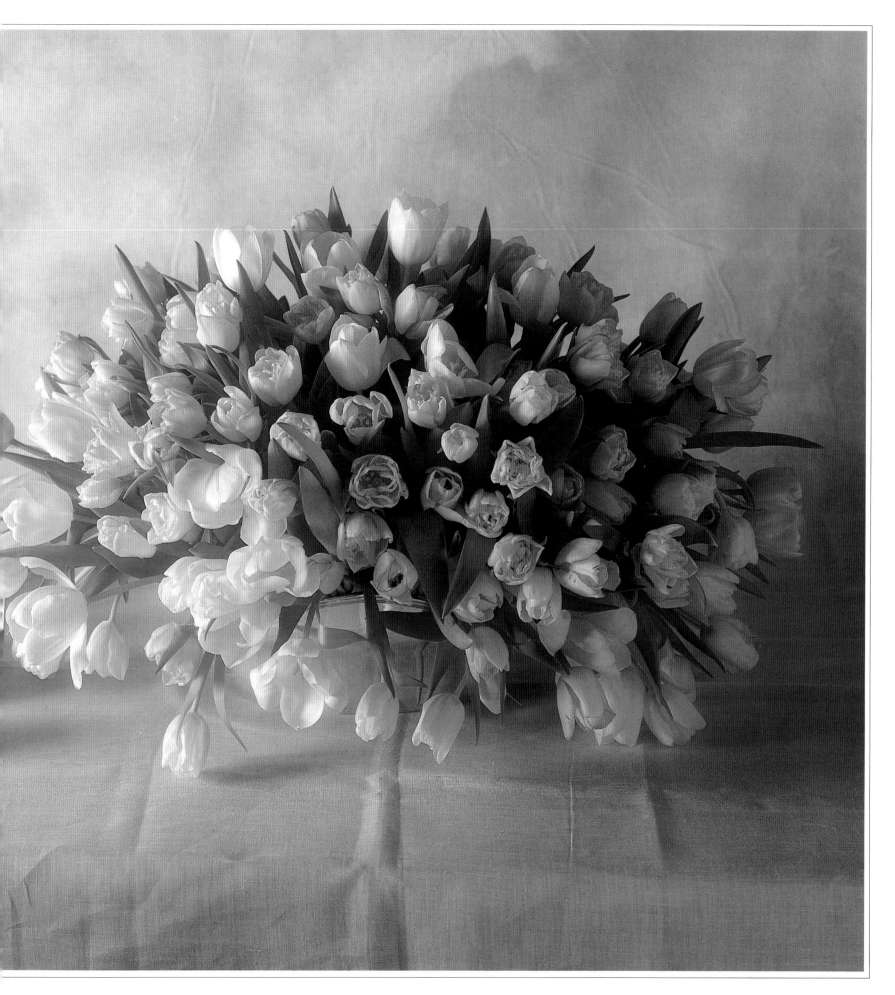

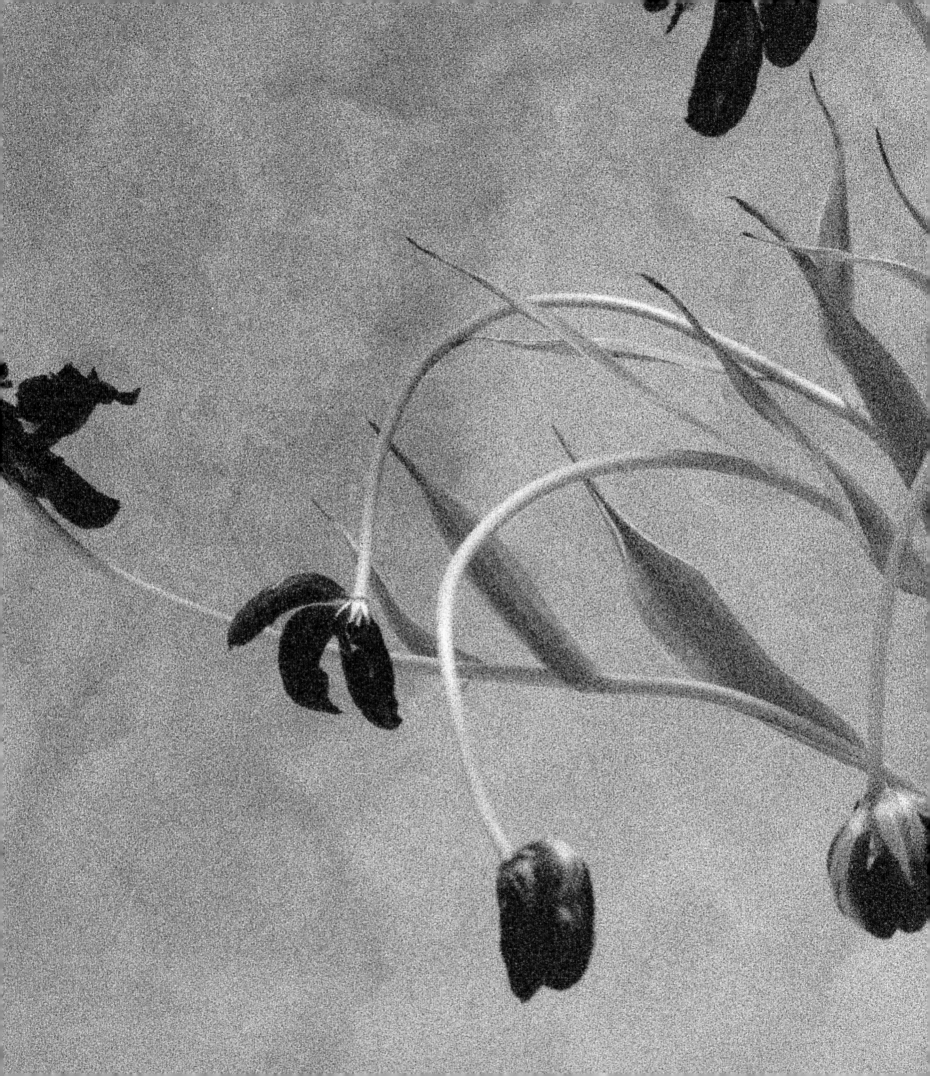

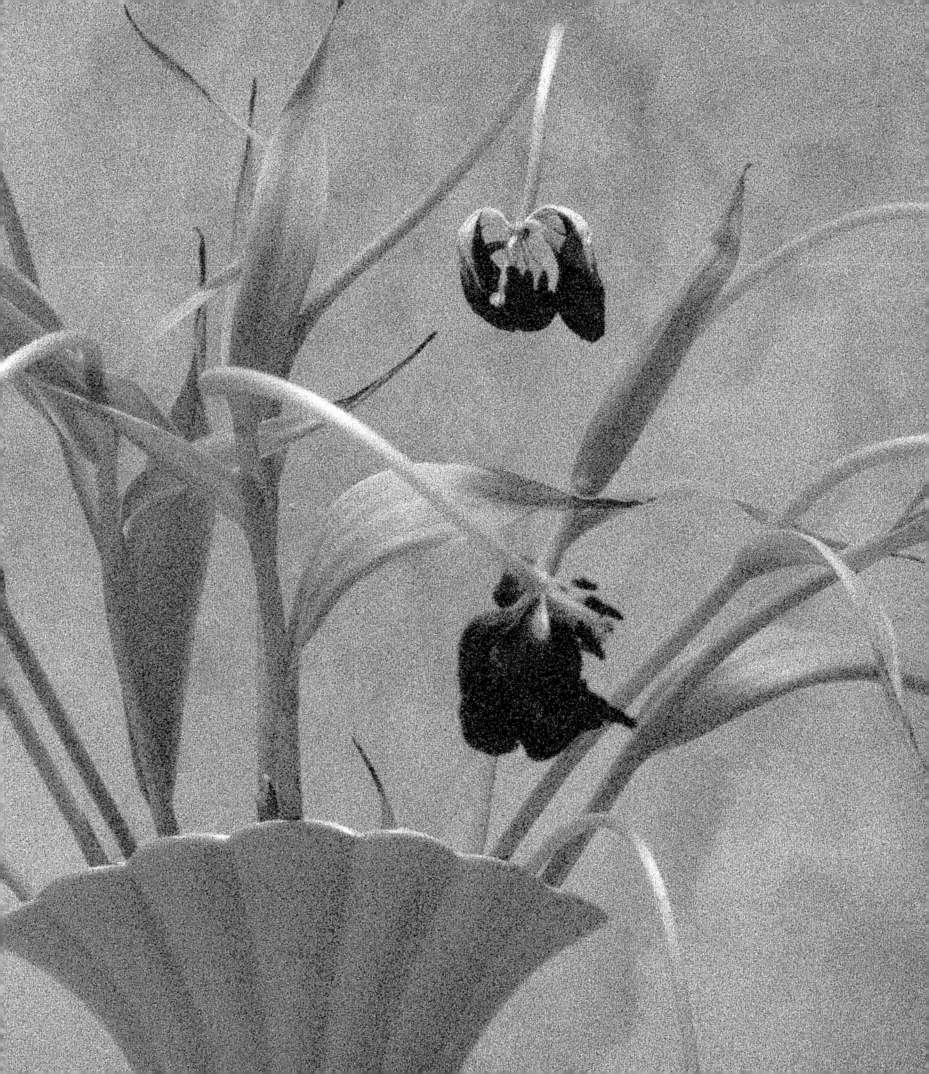

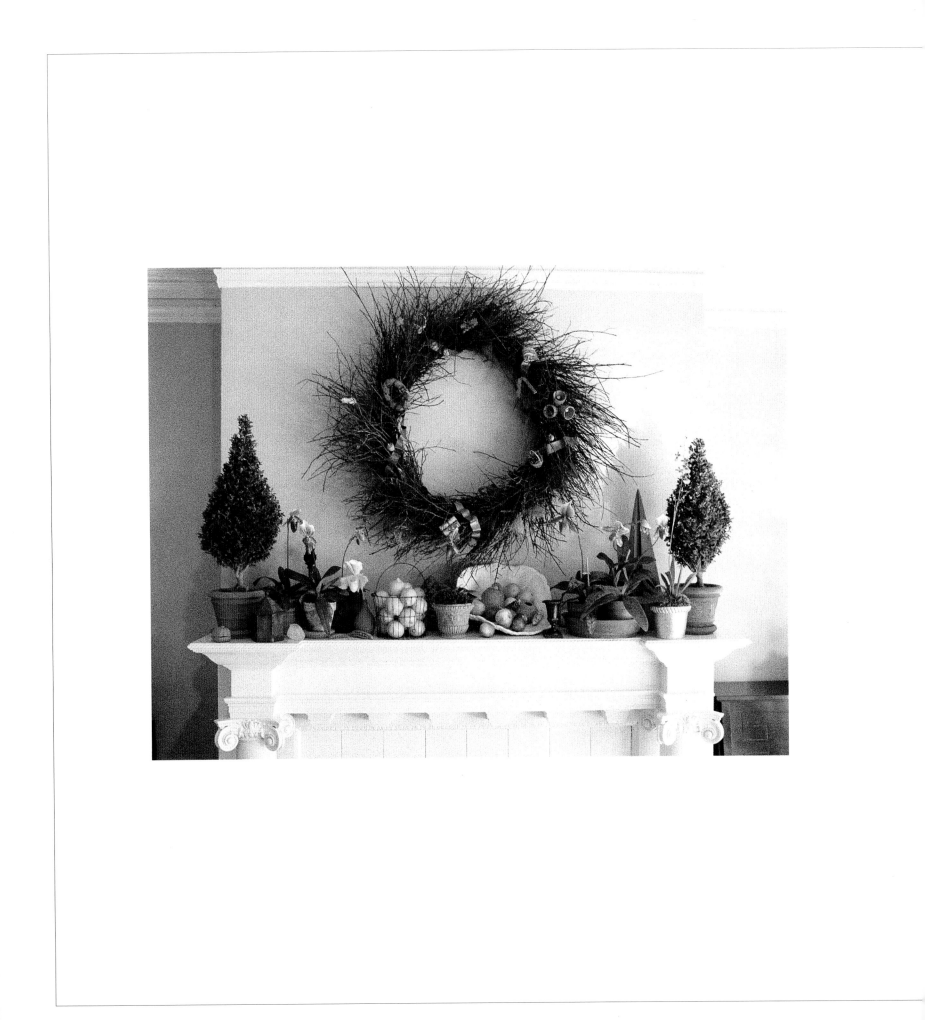

Orchids seem the ultimate ornamental flower. They grow in rare and exotic places, in inaccessible corners of the tropics, in hothouses, in trees, on mountains at altitudes up to 14,000 feet. Unless Nature does the growing, orchids can require great care and patience; some species take from five to ten years to develop from seed to flower. Orchids have their practical side as well, the genus *Vanilla* yields seeds that are fermented into cooking vanilla.

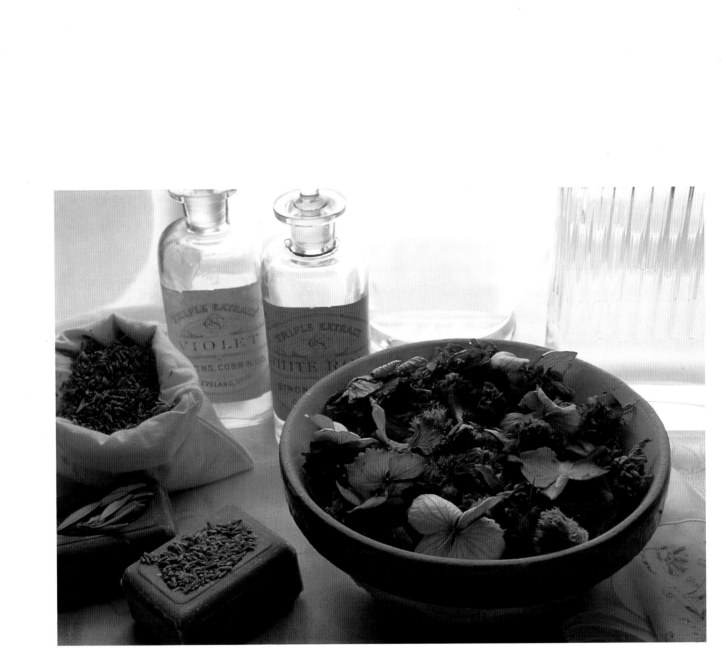

Legend has it that the first attar of roses was collected on the wedding day of the Indian Emperor, Jehan Ghir. He and his new bride walked along the canals that wound through the rose gardens and breathed in the fragrant air. They noticed an oily substance on the surface of the water surrounding fallen rose petals and arranged to have it collected.

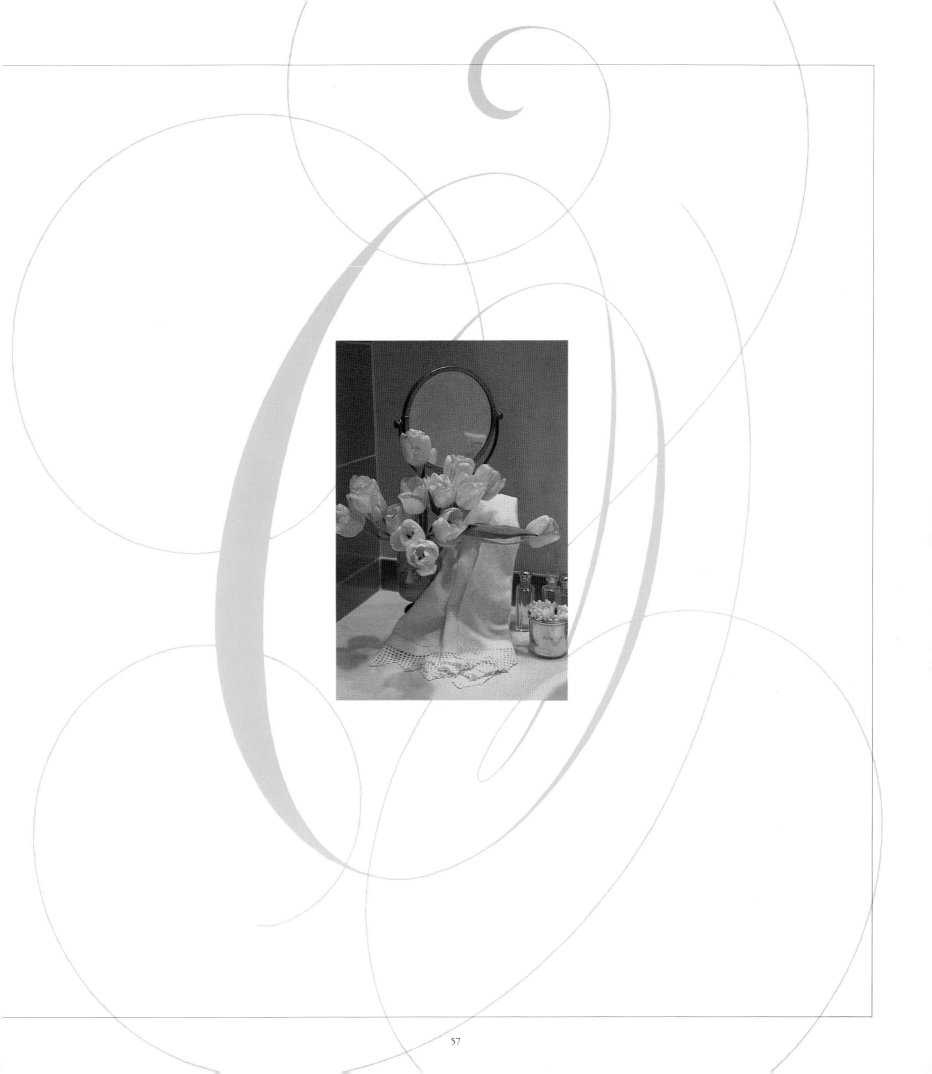

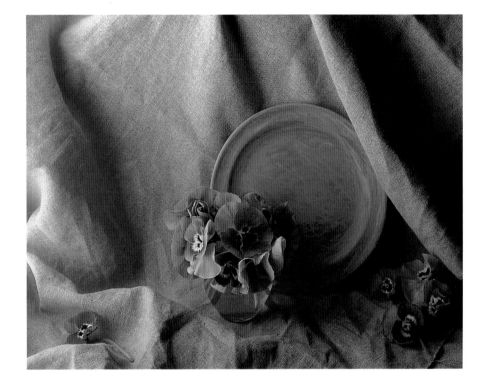

Flowers have faces as distinctive and individual as people. The French believed that the pansy

had a pensive or thoughtful face and dubbed it herbe de la pensée, the flower of thought or

remembrance. English gardeners took up the word pensée and Anglicized the spelling to pansy.

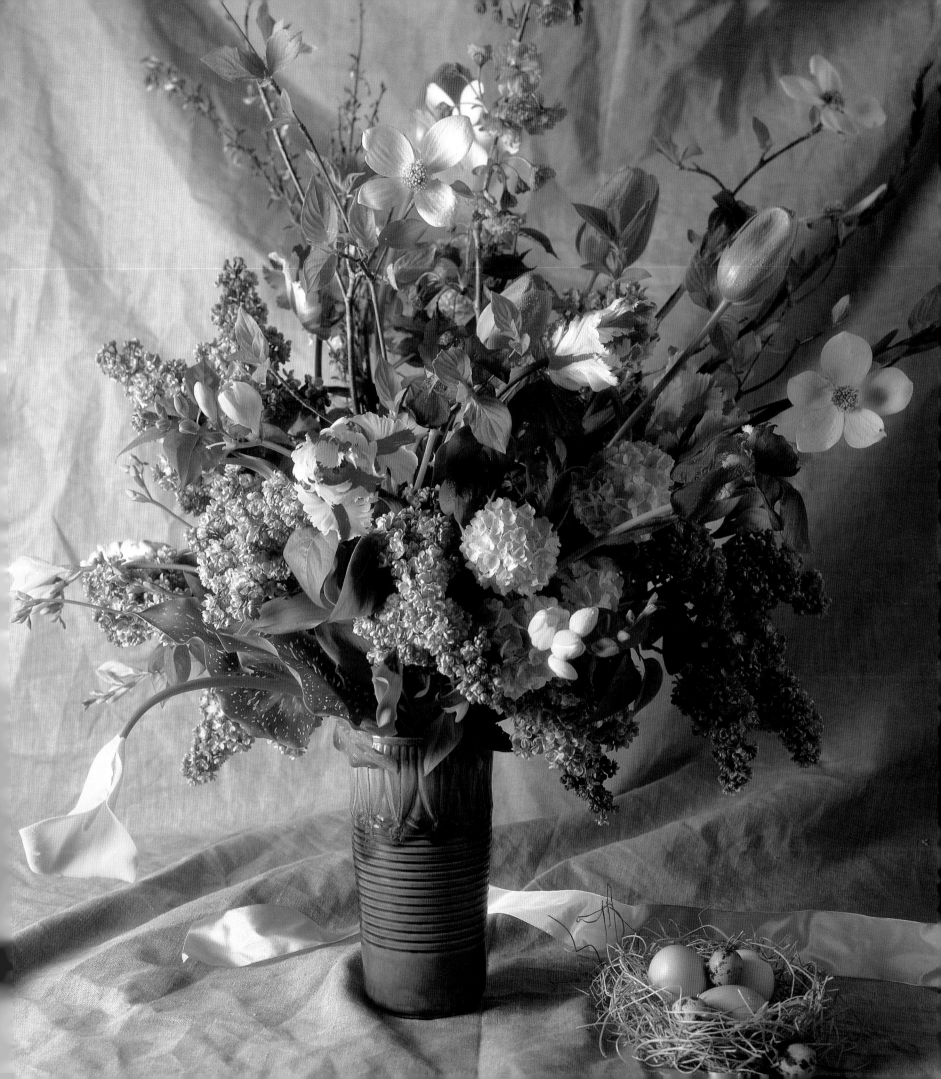

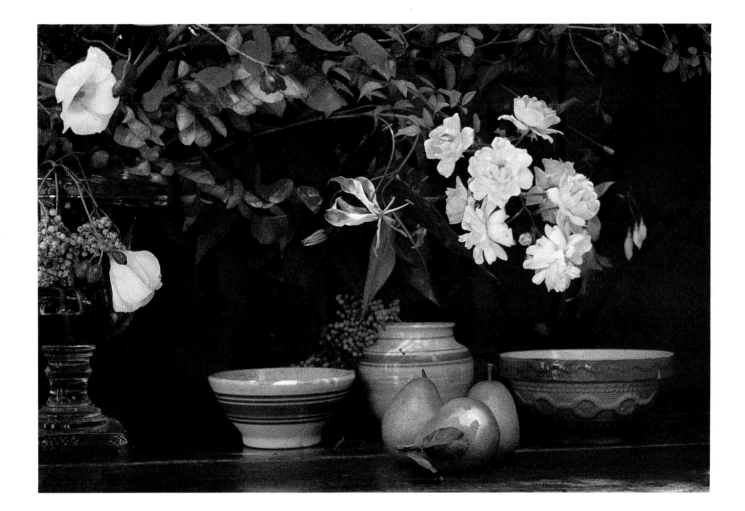

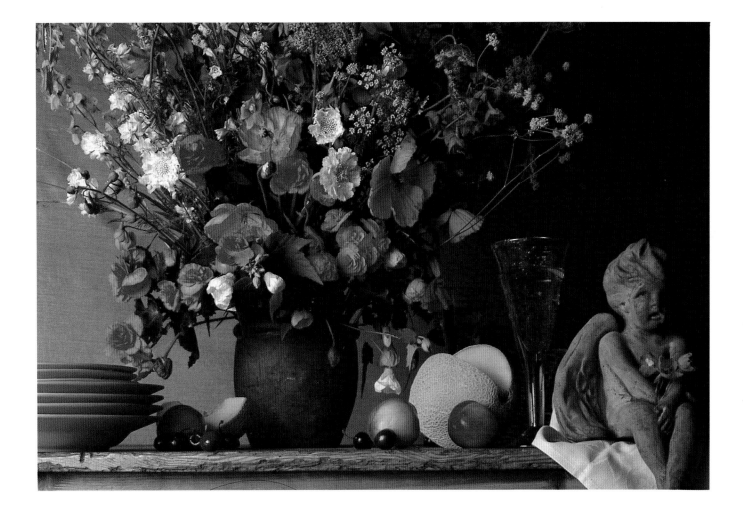

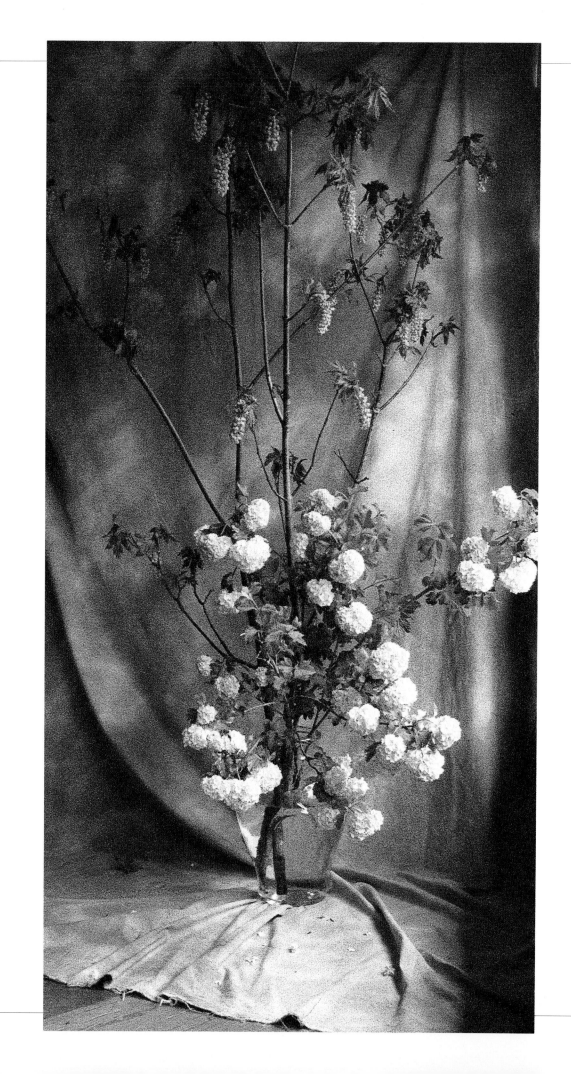

A Chinese fairy tale tells of the gardens of the Western Queen Mother in the land of perpetual bloom. It is the story of the peach thief who promises the governor and everyone in the town square that he can produce any fruit in any season.

The governor asks for a peach. From a bamboo box, the peach thief pulls a coil of rope, hundreds of feet long, and throws it into the heavens. It stays there, as if suspended from the sky. As the crowd watches, the peach thief sends his young son, climbing, climbing into the heavens. The boy disappears into the clouds. The father waits, then suddenly a peach falls to earth. The peach thief presents it to the governor.

A cheer goes up, but it turns to gasps when moments later the son himself falls to earth— in pieces. The old peach thief sadly packs the pieces of his son away in the bamboo box. Shocked and heartbroken, the crowd presses funeral donations upon him. He accepts the gifts gratefully, tucks them away, and then knocks on his bamboo box. "You can come out now, my son," he says, "and thank the generous donors." The box flies open and out jumps the son, sound of body and wreathed in smiles.

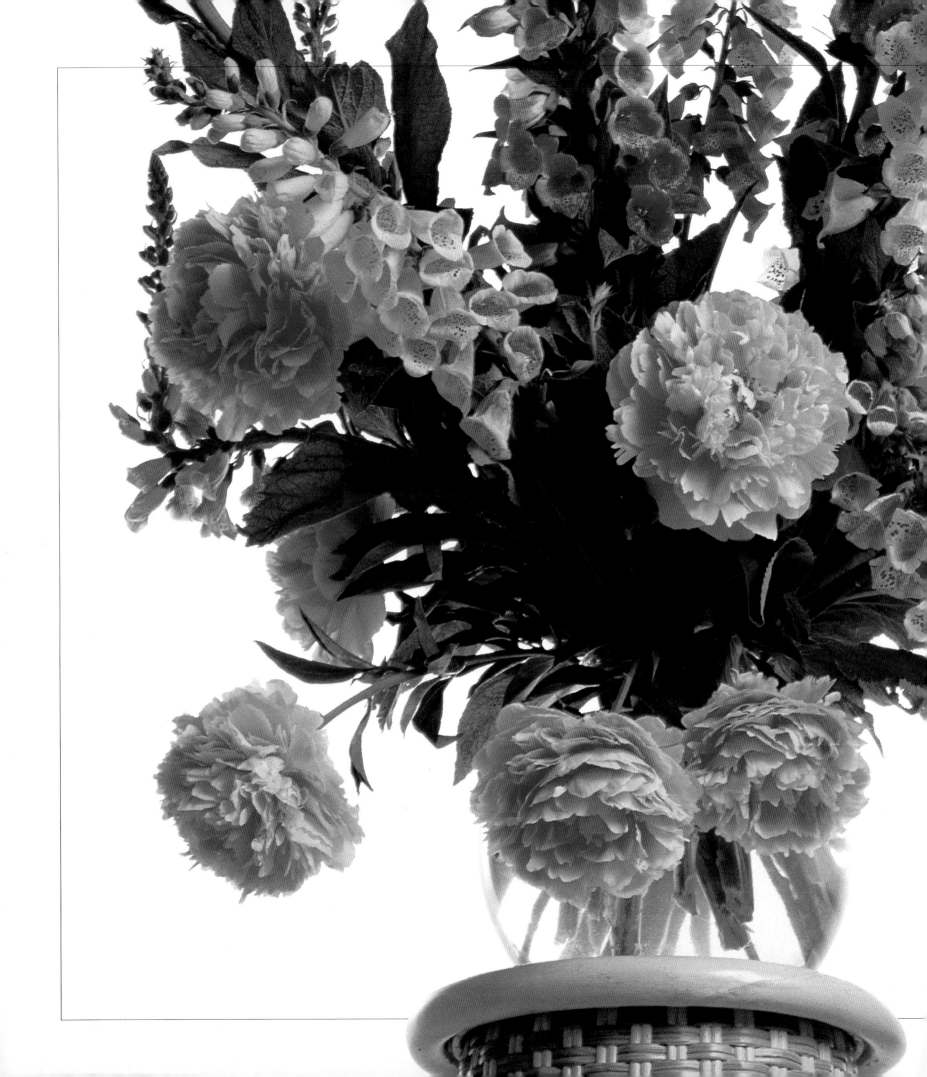

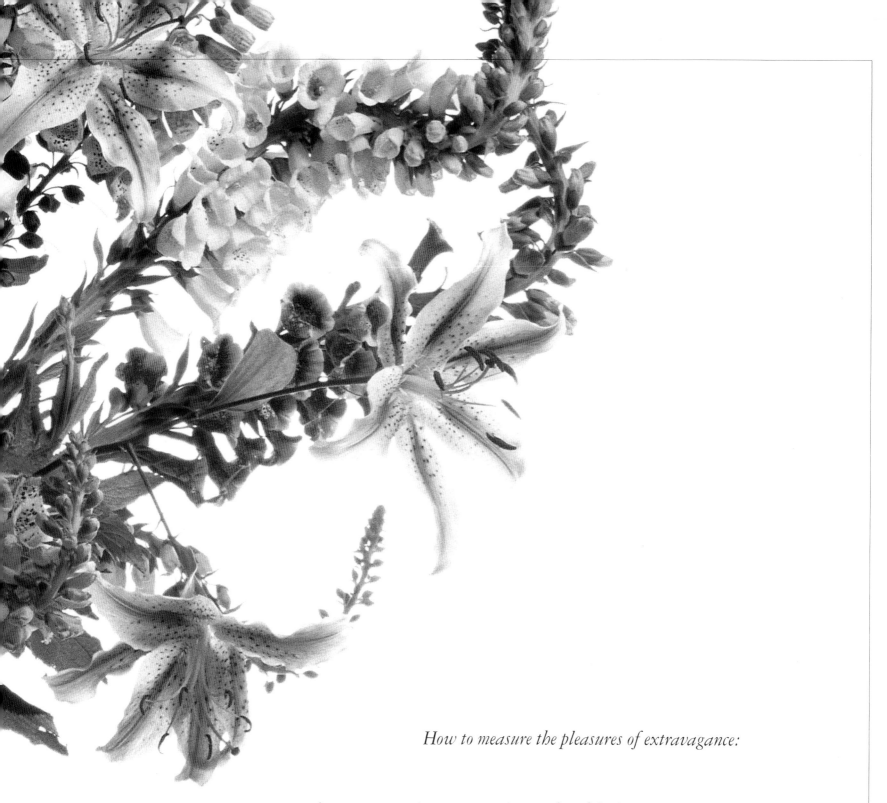

How to measure the pleasures of extravagance:

not in carats, not in acres, not in numbered Swiss accounts.

Take your measure in armsful of blooms.

> *"'O Tiger-lily,'*
> *said Alice, addressing*
> *herself to one that*
> *was waving gracefully*
> *about in the wind,*
> *'I wish you could talk!'...*
> *'We can talk,' said*
> *the Tiger-lily, 'when*
> *there's anybody*
> *worth talking to.'"*
>
> Lewis Carroll,
> Through the Looking-Glass
>
> *In a vase or a jug, flowers*
> *make splendid companions—*
> *beautiful, open-minded,*
> *willing to listen, and quite*
> *content to wait a long, long*
> *time for their turn to talk.*

- - - - -

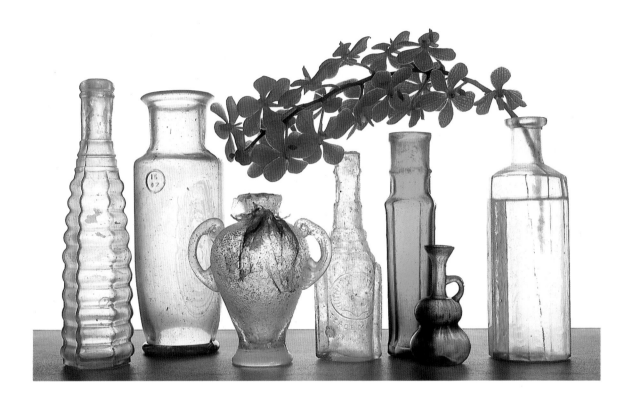

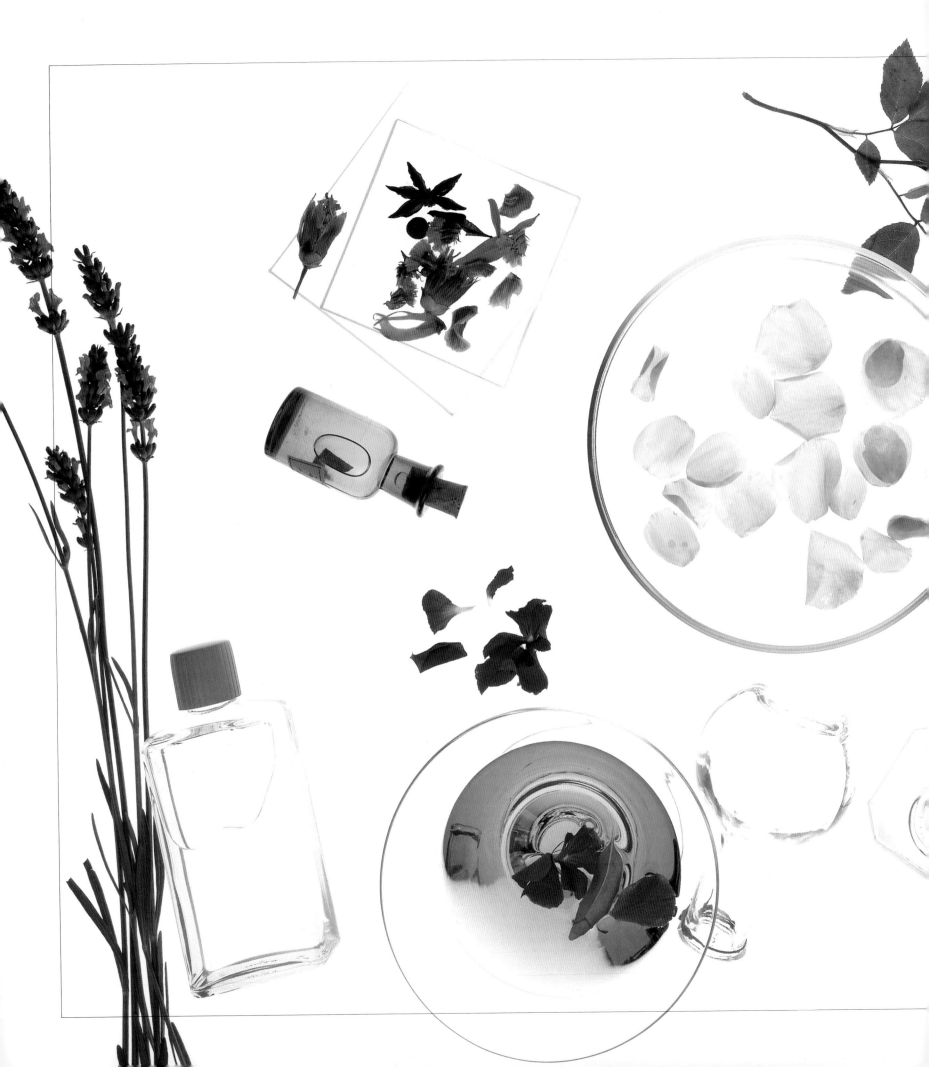

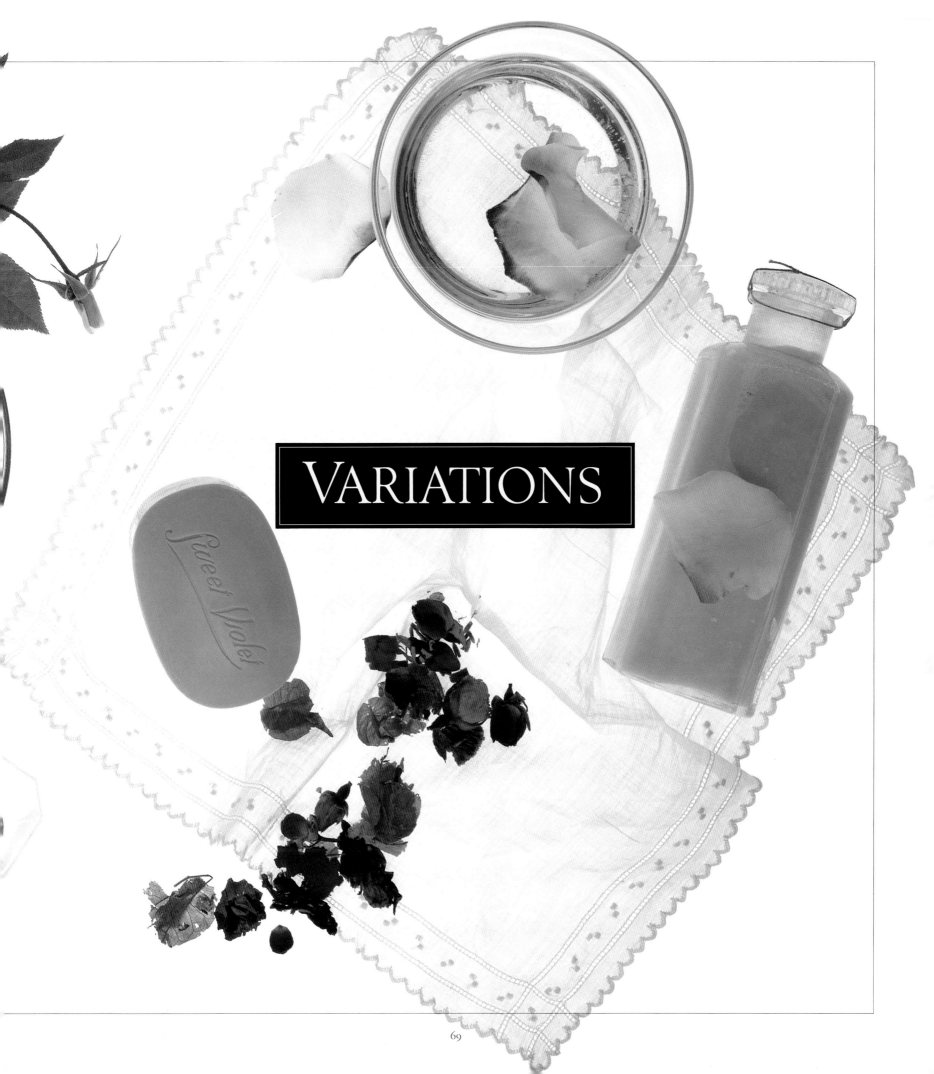

VARIATIONS

Hand-tied bouquets. Potpourri. Perfumes. Attars. Wreaths. Remedies. ¶ The true flower lover is never limited by so pedestrian a concept as the vase. ¶ Flowers are Nature's best and most extravagant ornaments. The opportunities to learn about ornamentation from Nature herself are endless. Consider the lilies of the field, those Biblical miracles that turned a field of grass, overnight, into a sweep of color. The lilies that "toiled not, neither did they spin," were in fact probably anemones that grew in Galilee. ¶ Sometimes the variations in which we see flowers are miracles, not of ornament, but of desperation. During the cold, bleak winters between 1940 and 1945, when Germany occupied Holland and food was scarce, many Dutch dug their tulip bulbs out of the garden. Scrubbed clean, the bulbs were baked or boiled, then eaten to ward off starvation. ¶ Then, there was the rebellious young doctor, Edward Bach. Though he had a prosperous practice on London's exclusive Harley Street in the 1930s, he gave it up

Look again at carnations, those florists' clichés. In 1793, the Chevalier de Rougecille concealed, in the calyx of a carnation, news about a plan to rescue the imprisoned Marie Antoinette, then dropped the flower at her feet. Alas for the French queen, the guards intercepted her reply.

to develop a branch of herbal medicine. He used nonpoisonous flowers to create remedies for mental and emotional distress. Homeopaths still respect the Bach Flower Remedies, named for the gentle man who attacked Loneliness and Despair with Nature's own prescriptions. Antibiotics can't relieve grief, but Bach believed the larch or the Star of Bethlehem could. ¶ He offered no complex scientific explanation to support his remedies. Instead, he traveled the countryside of England and Wales, gathering flowers and working on new remedies. He wrote, "And may we ever have joy and gratitude in our hearts that the Great Creator of all things, in His Love for us, has placed the herbs in the fields for His healing."

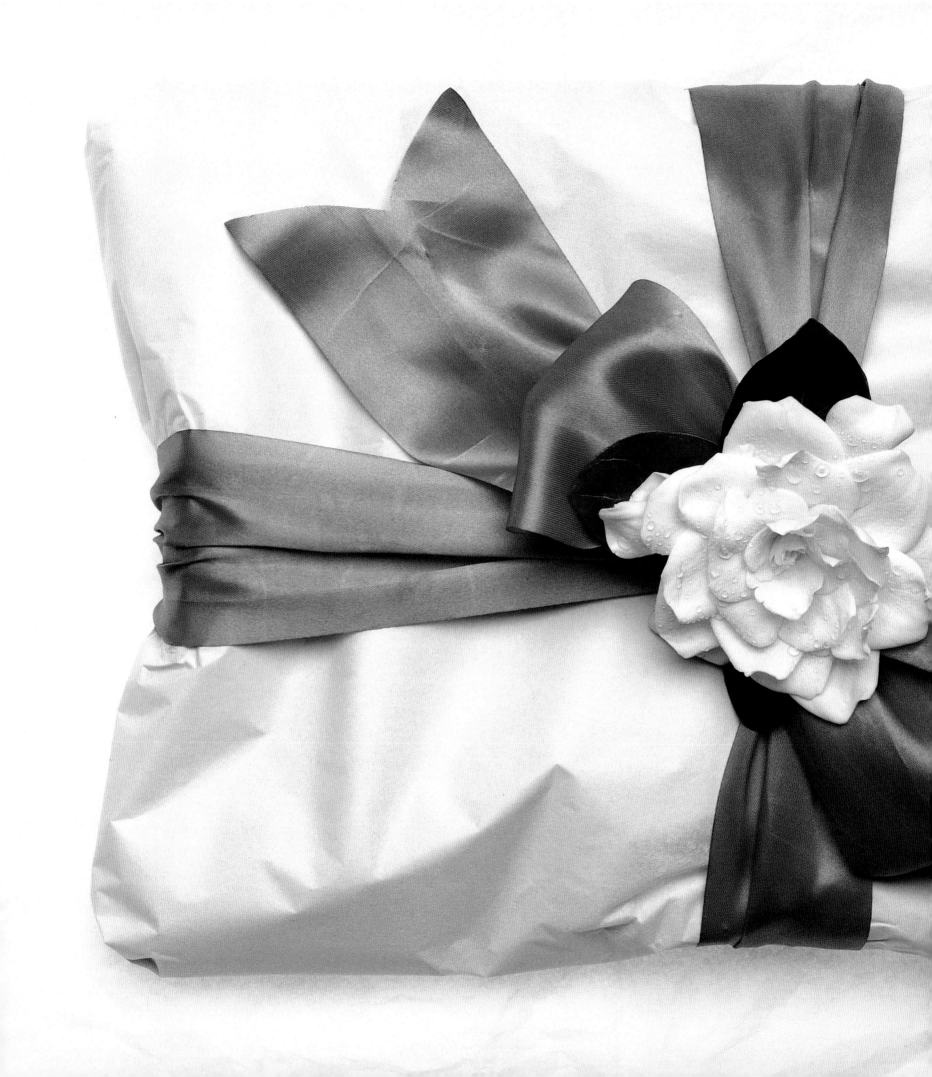

H istory is
unclear on the subject of gift
giving. There were the three Wise
Men, of course, with gold,
frankincense, and myrrh. There
were the Greeks and that
untrustworthy gift horse. There
were Native Americans shower-
ing neighbors with potlatch gifts,
designed to show off their
wealth. But the sweetest gifts
deliver their sentiments
before they are even opened.

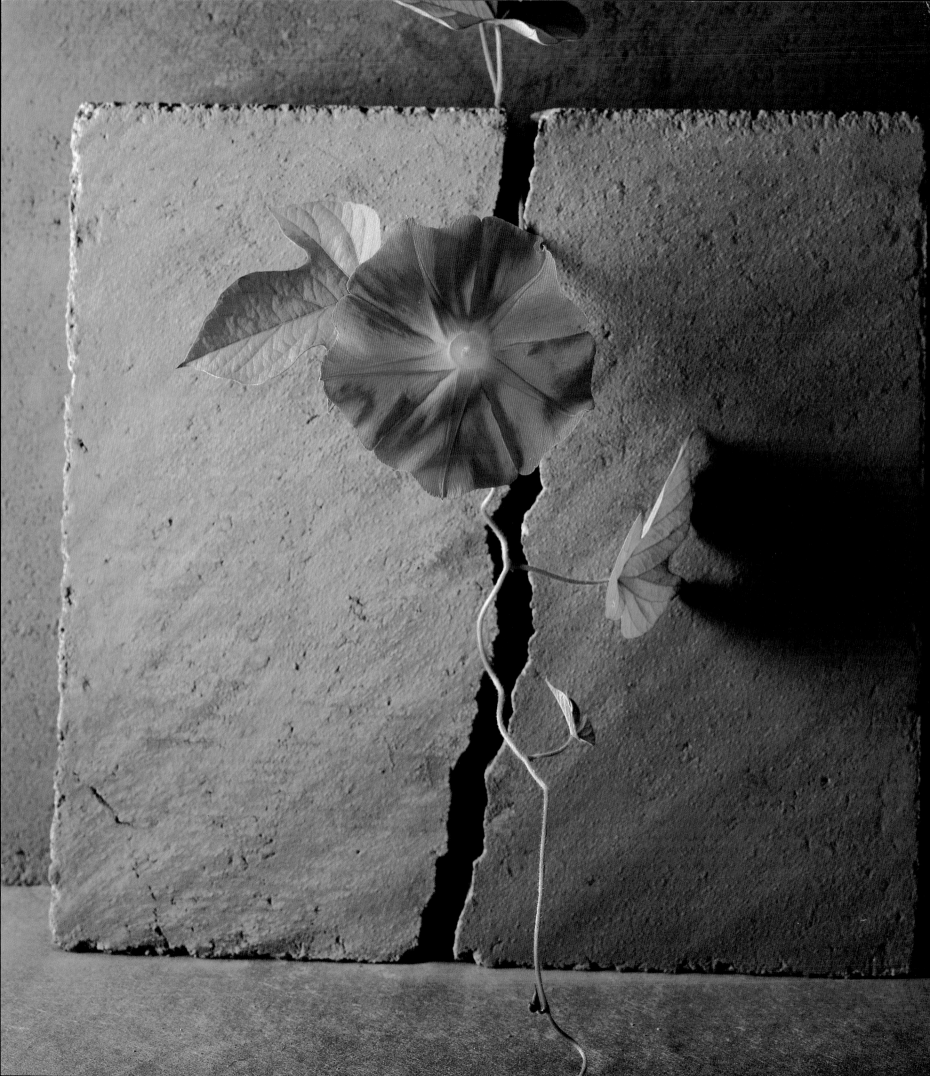

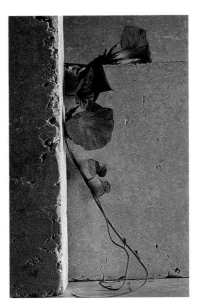

The morning glory was a rare treasure in sixteenth-century Japan. One man had filled his garden with morning glories, through great care and cultivation. The Taiko heard of the magnificent garden and asked to be invited for morning tea. When the Taiko arrived, he saw that the ground of the garden had been leveled and covered with pebbles and sand. Enraged, he entered the tea room. There on the toko-noma, the place of honor, lay a single morning glory, the most splendid of all that had been in the garden. The gardener had revealed to his guest the meaning of Flower Sacrifice.

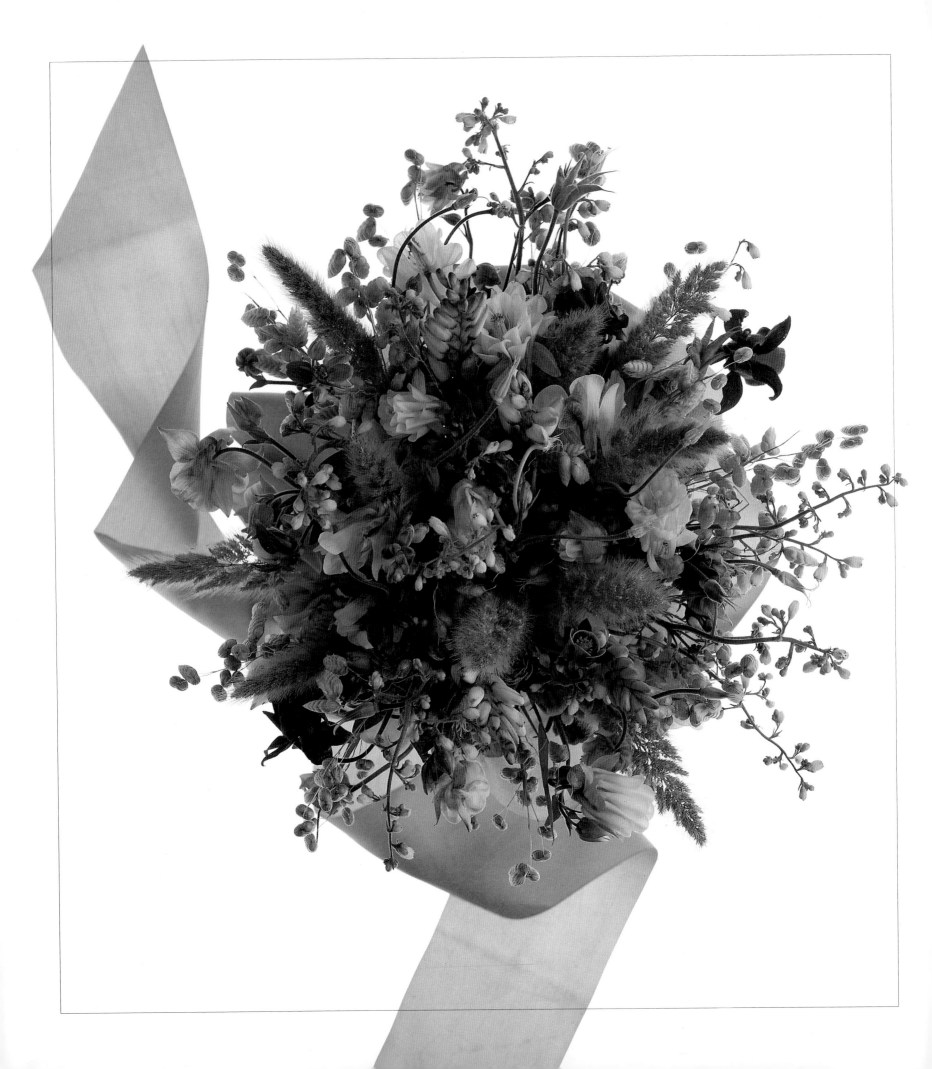

Flower lovers are inveterate fact gatherers: Dissolve a little Epsom salts in the water (1 tsp. salts to 1 quart water) when you bring your watering can around the geraniums, and they will bloom prolifically. Or force a rosebud open early by choosing buds that feel a bit soft to the touch, then blow hard into the top of the bud. Or bury nails in the ground around your blue hydrangeas, and their color will deepen. ¶ Sound principles of botany are involved in most of these old wives' tales. Even flower arranging includes principles of aesthetics, made to be followed, and broken. Some flower arrangers employ what is called the Hogarth Curve. William Hogarth (1697–1764), an English painter and engraver, saw beauty in curves rather than geometric shapes. In 1745, he painted a self-portrait posed beside his dog, Trump. The painting hangs in the Tate Gallery in London, and if you visit it, you'll see a palette in the painting, inscribed with a lazy, serpentine line and the words, "line of beauty." ¶ Later, in his *Analysis of Beauty,* Hogarth explained that he considered this curve the most perfect figure humans could devise. In classic flower arrangements it has become a guideline for creating pleasing shapes. ¶ A love for variations frees you to consider the curve and then abandon it, or to create your own curve simply by gathering flowers in every tone of pink, purple, and cream and tying them up with ribbon.

RUSSELL PAGE

The Education of a Gardener by Russell Page, first published in 1962, remains a classic text filled with useful information. It is, like the author himself, lively and respectful both of the landscape and of amateur gardeners. Page's study of English, French, Italian, and Japanese gardening traditions resulted in an extraordinary and individual sense of color, design, and style. "I never saw a garden from which I did not learn something," he wrote.

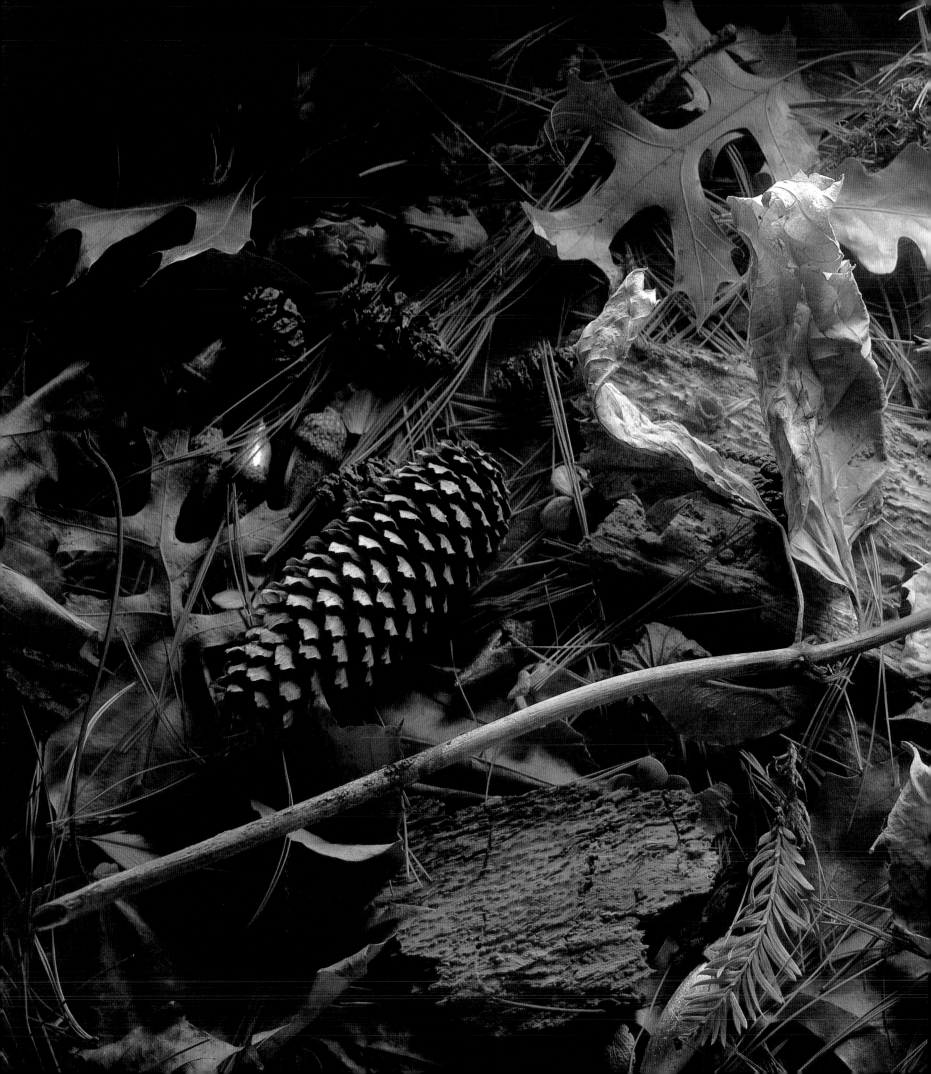

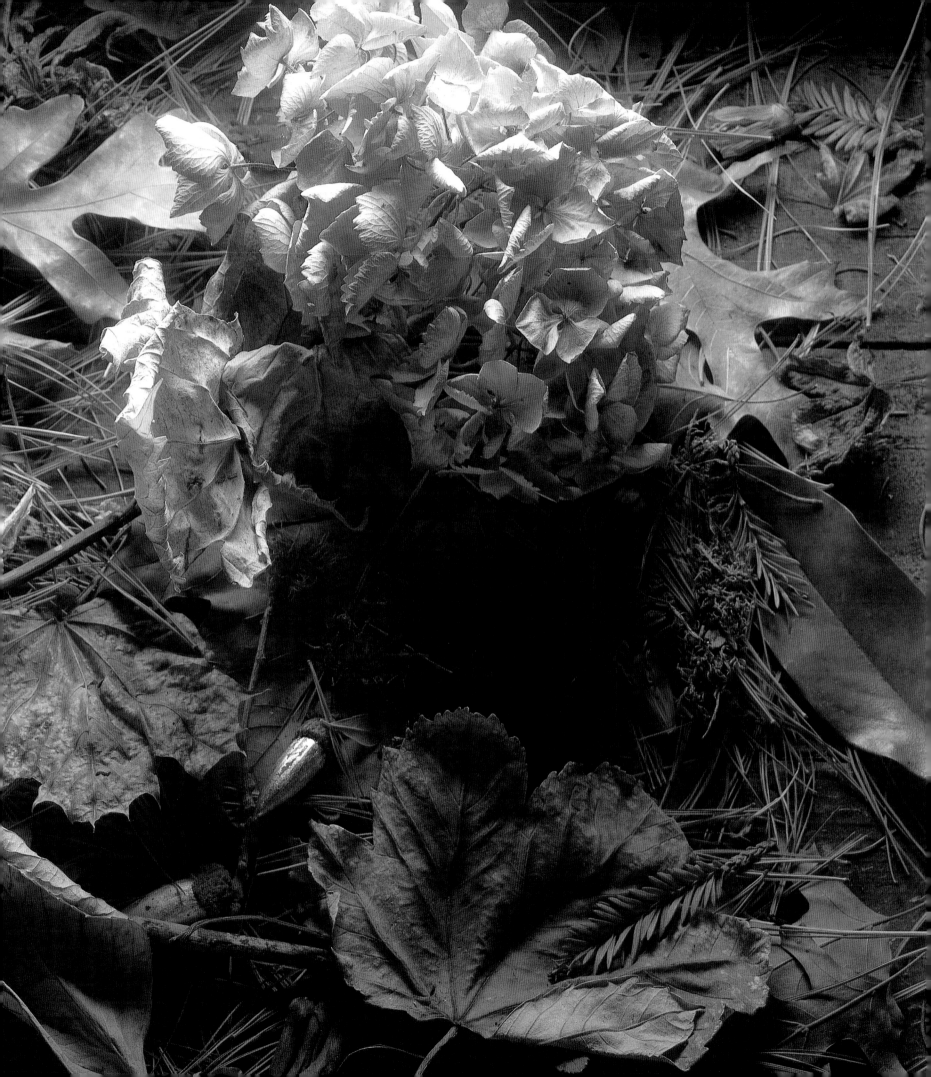

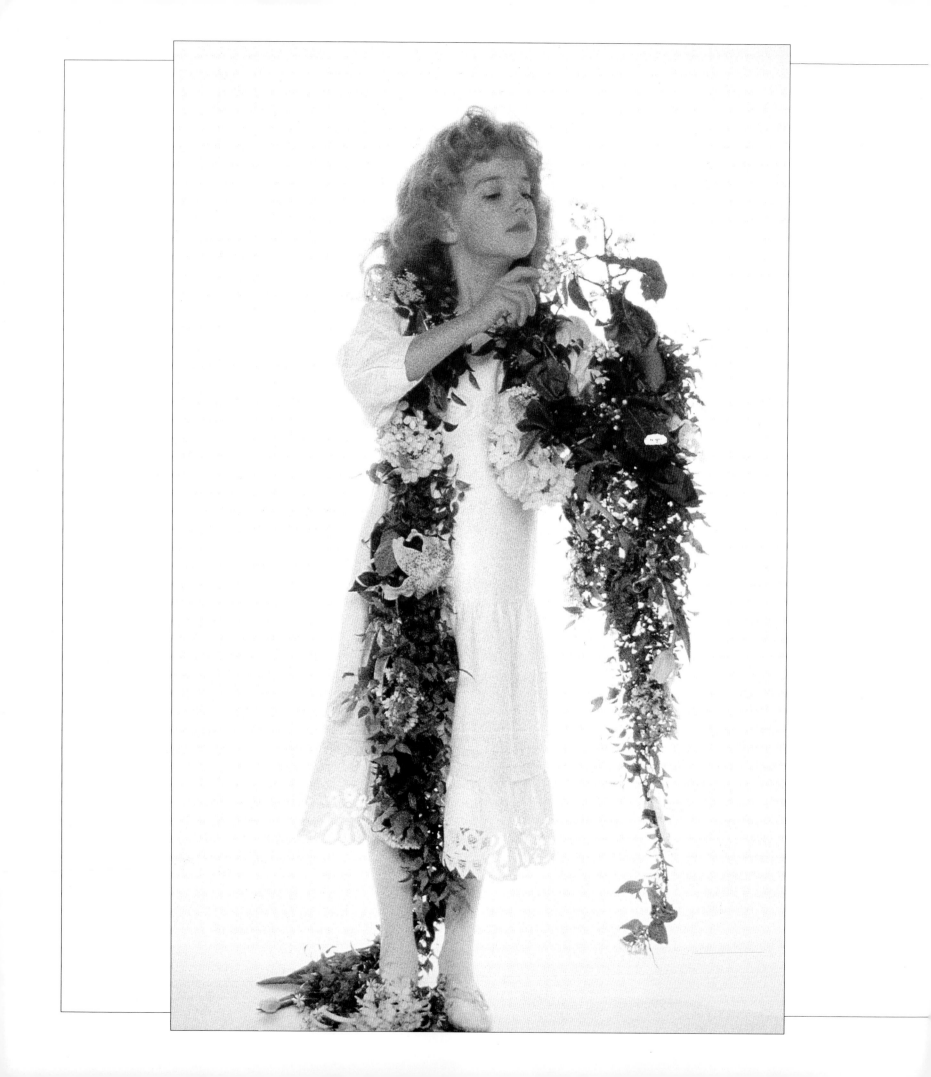

"One Christmas was so
much like another,
in those years around
the sea-town corner
now and out of all sound
except the distant
speaking of the voices I
sometimes hear a
moment before sleep,
that I can never
remember whether it
snowed for six days
and six nights when I
was twelve or wheth-
er it snowed for twelve
days and twelve nights
when I was six."

Dylan Thomas,
A Child's Christmas in Wales

Of the many stories about
St. Nicholas, the fourth-
century prelate who
became the patron saint
of Russia, sailors,
and children, the old
stories are best,
and the most beautiful.
It seems that once
upon a time, the good
bishop heard about
a town far away where
people went hungry,
even the children. He
asked his servants
to bring him "the fruits
of your gardens
and the fruits of your
fields," to feed those
far-off children.

His servants were kind
and generous people,
so they gathered great
baskets of fruit,
grain, and delicious
honey cakes. The
bishop collected the
gifts and sailed
away to the poor and
hungry town. He
arrived at night, and in
the darkness, he
crept to the first lighted
house and knocked on
the window. The mother
inside asked her
small child to see who
knocked so late.
When the child looked
outside no one was
there—at the door or
at the window. But
in the snow stood baskets,
filled to overflowing
with fruit and grain for
the town.

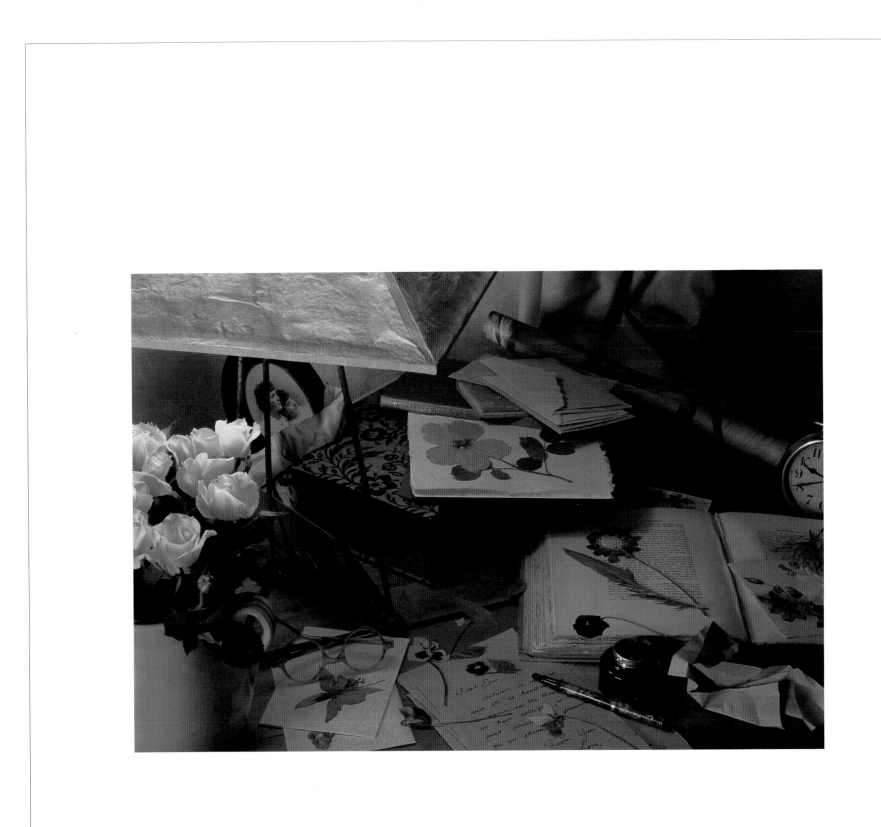

Seven memories from a book of pressed flowers: sunflowers from your own corner of your mother's garden, all the "loves-me, loves-me-not" petals from a first passion, dried lupin gathered in Tuscany and brought home in the pages of a passport, lavender meant for the linen closet, baby's breath and red ribbon from a Christmas tree, honeysuckle collected when you taught the grandchildren how to sip the nectar.

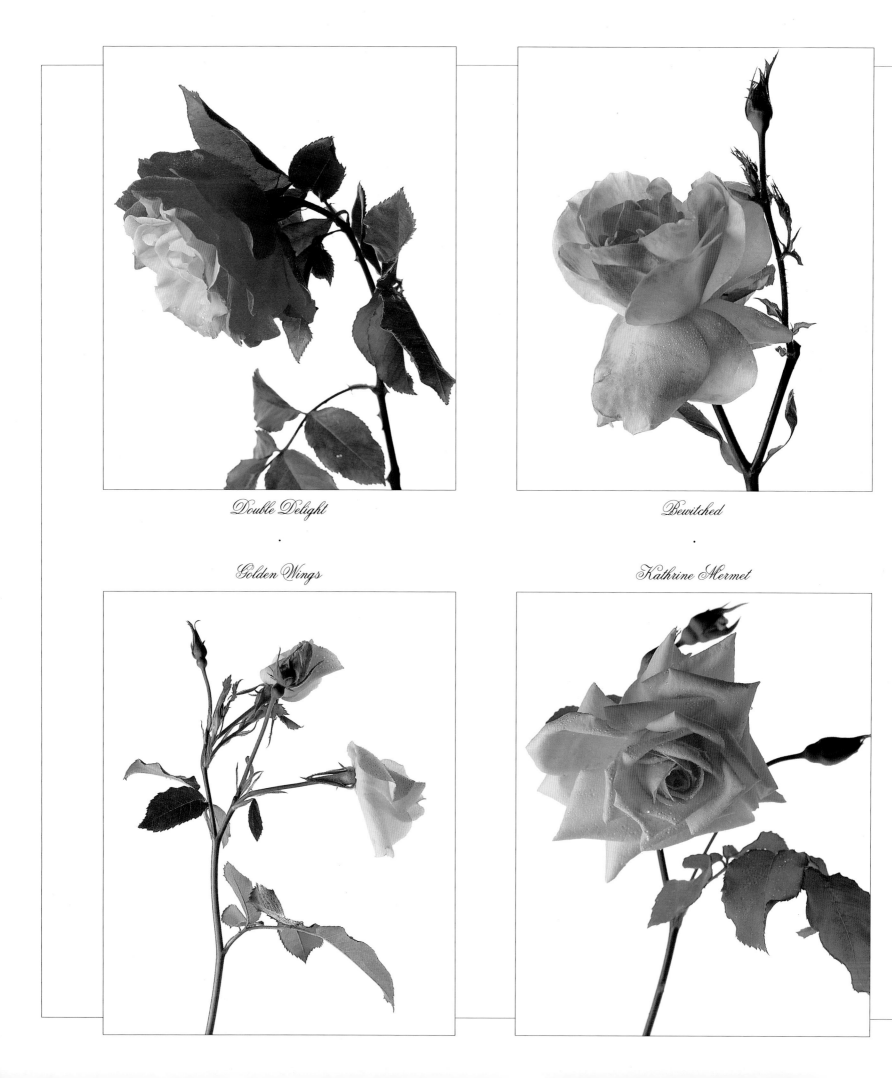

Double Delight

Bewitched

Golden Wings

Kathrine Mermet

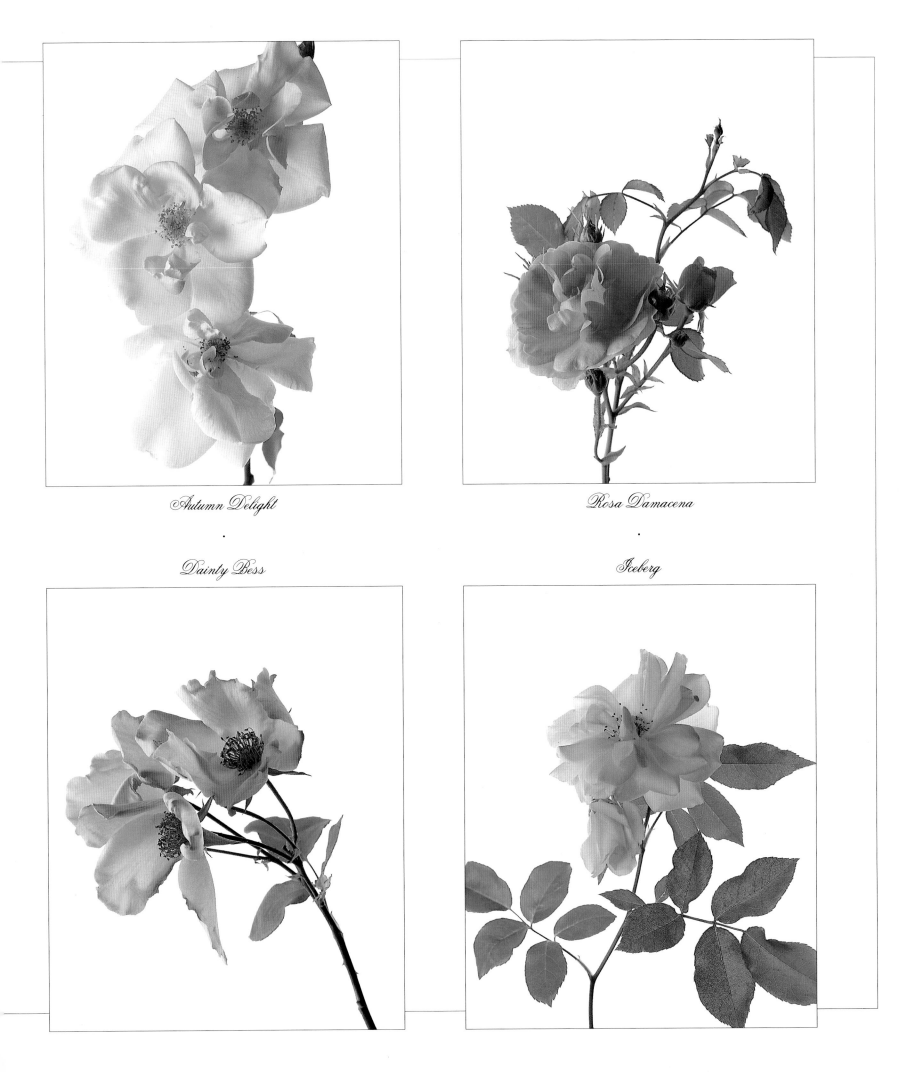

Autumn Delight

Rosa Damacena

.

Dainty Bess

Iceberg

.

If you think tulips are a luxury for Christmas, consider this: In the seventeenth century, the Dutch aristocracy began importing tulip bulbs from the Orient. Tulip mania struck! One Dutchman offered twelve acres of land for a single bulb, another went to jail for eating a rare bulb he had mistaken for an onion.

otpourri—what a wonderful word! French for "rotten pot," it defines an actuality far more pleasant, a lovely mixture of dried sweet-smelling flower petals. Make your own by gathering fresh petals and flowers at noon on a dry day. Separate the petals, then place them on wire screen trays in a well-ventilated room to dry out. Don't begin mixing potpourri until every petal is dry, or you'll chance mildew. Combine rose petals with anything you like—rosemary, lavender, dried and powdered orange skin, powdered clove, borage flowers.

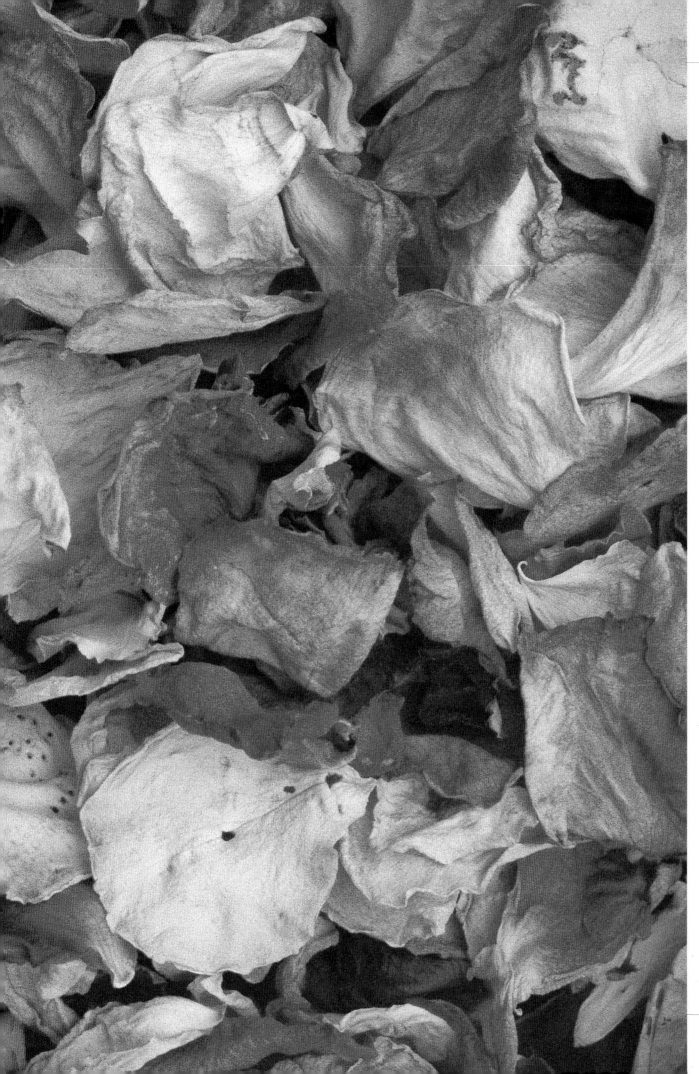

Michaele Thunen's
Blue Potpourri

1 oz. malva (mallow)
 blossoms
1 oz. bachelor's button
 blossoms
½ oz. bachelor's button
 petals
4 oz. lavender
1 oz. blue belladonna
1 oz. blue hydrangea
1 oz. blue delphinium
1 oz. purple statice
4 oz. woodruff
1 oz. dusty miller leaves
1 oz. juniper berries
8 oz. crushed orris root
⅛ oz. oil of neroli

Combine elements in large bowl and toss with oil. If scent fades over time, add a few drops of oil and toss again.

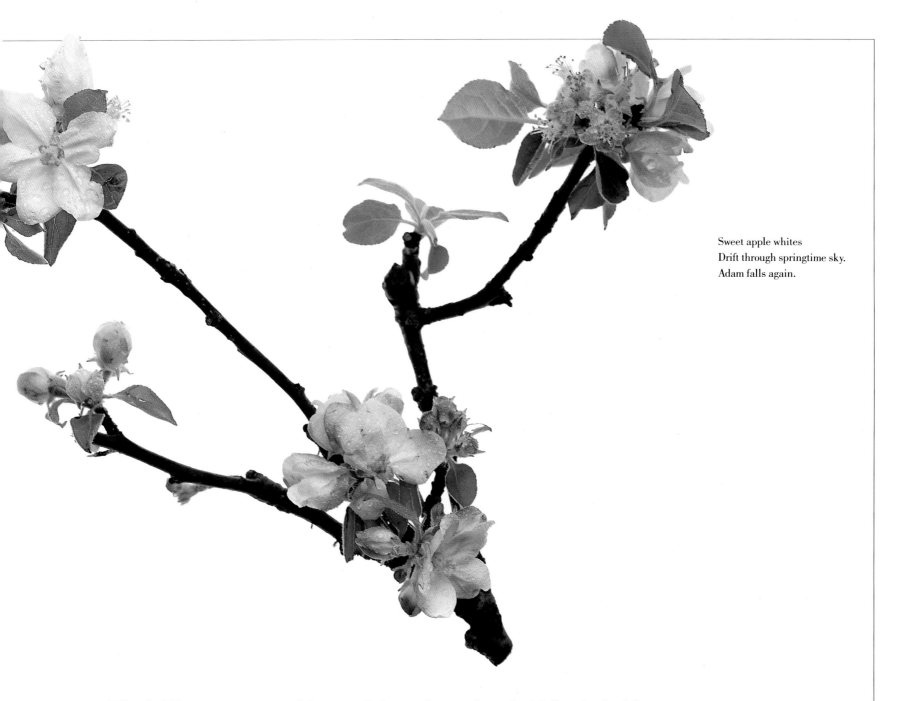

Sweet apple whites
Drift through springtime sky.
Adam falls again.

Why did Eve wait to tempt Adam until the apple tree bore fruit? Surely the blossoms,

fragrant and white, were temptation enough.

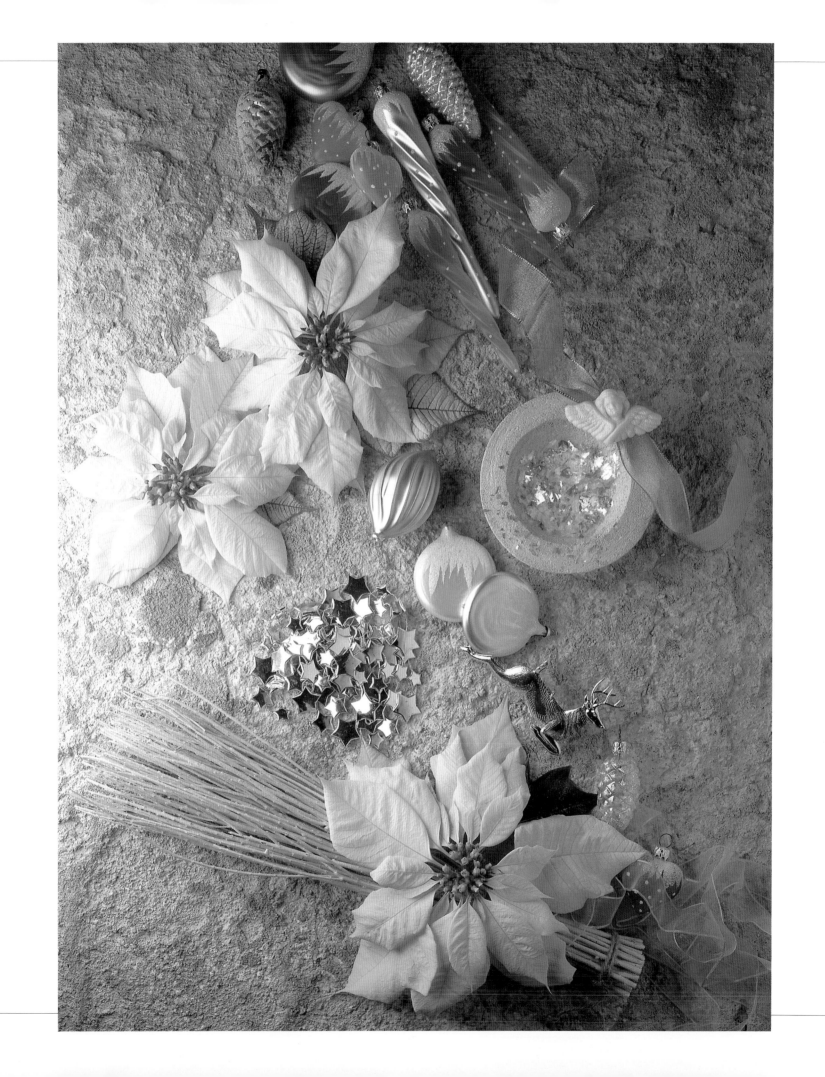

Flowers for Those Who Did Not Go

In 1909, a London journalist named H.M. Tomlinson

resigned his job at the *London Morning Leader,* bade his wife and children farewell, and

signed on as purser on the freighter *Capella.* The *Capella's* destination was the upper

Amazon, and this journey was far out of character for a newspaperman who had de-

scribed himself as solid and settled. ¶ But go he did, probably teased into the journey

by his seafaring brother-in-law, and his account of the journey, *The Sea and the Jungle,*

was dedicated "To those who did not go." ¶ The book, which was the first of many travel

books Tomlinson was to write, captures the richness, the exotica, and the sheer un-

broken mass of the jungle. He creates an imagined Amazonian place: "Trees are always

in blossom there, for it is a land of continuous high summer, and there are orchids

always in flower, and palms and vines that fill acres of forest with fragrance, palms and

other trees which give wine and delicious fruits, and somewhere hidden there are the

birds of the tropical picture, and dappled jaguars perfect in colouring and form, and

brown men and women who have strange gods." ¶ The exotics—hibiscus, poinsettias,

frangipani—native to places few people go, stir our imagination with their wild beauty.

KATHARINE WHITE

Only Katharine White, consummate editor and passionate gardener, would think to review seed catalogs in the pages of *The New Yorker.* In 1958, she began a series of pieces titled "Onward and Upward in the Garden." Under that title, her garden-ing essays on everything from rose growers to garden club shows captured the common-sense, old-fashioned hearts and minds of true flower lovers. She wrote, "Flower arrangers are like yachtsmen; some prefer competition (yacht races and flower shows), some prefer sailing for its own sake (cruises and home bouquets)."

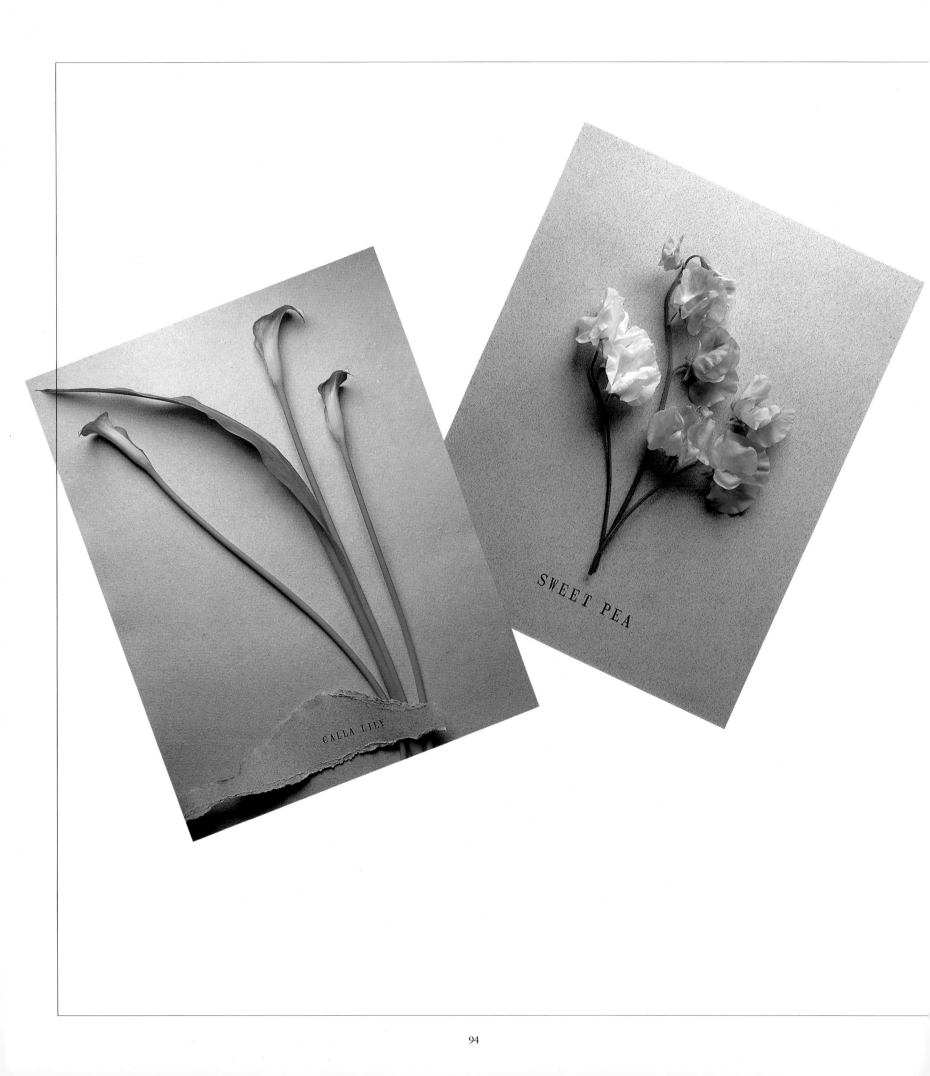

CALLA LILY

SWEET PEA

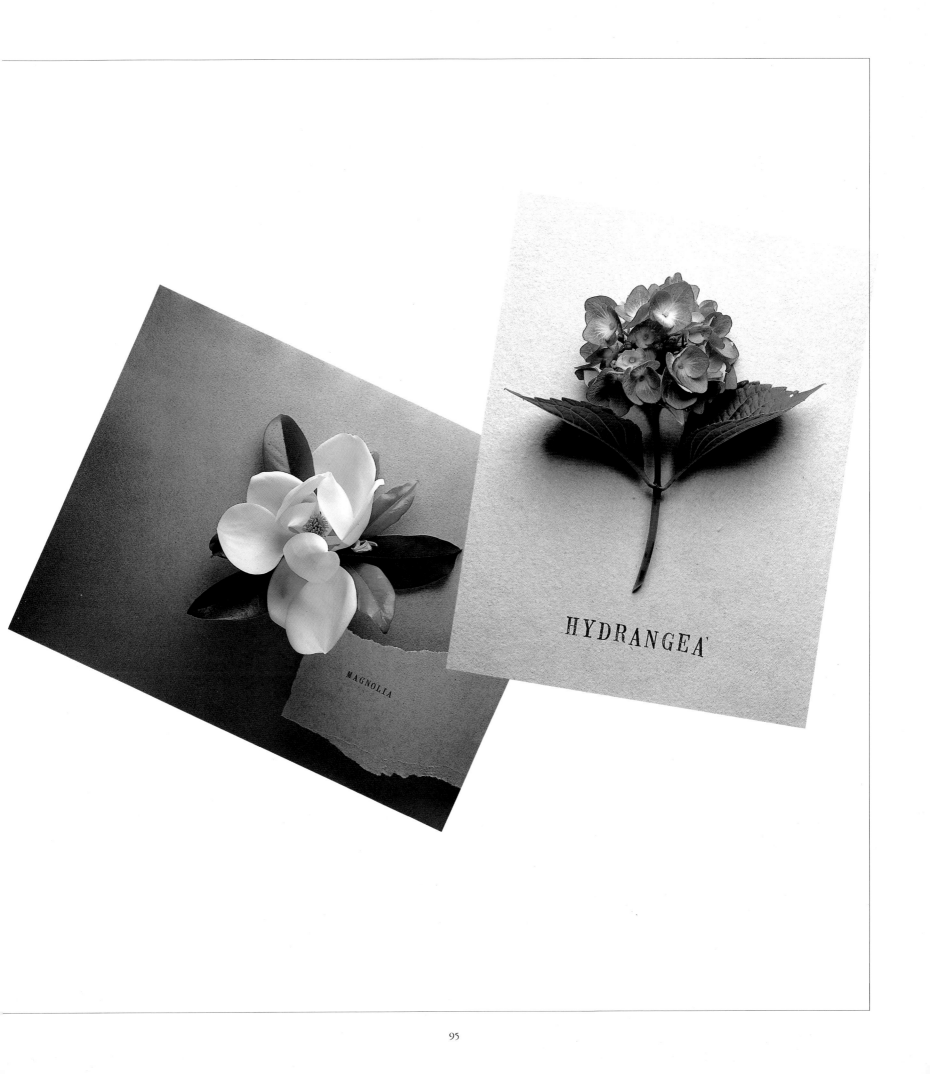

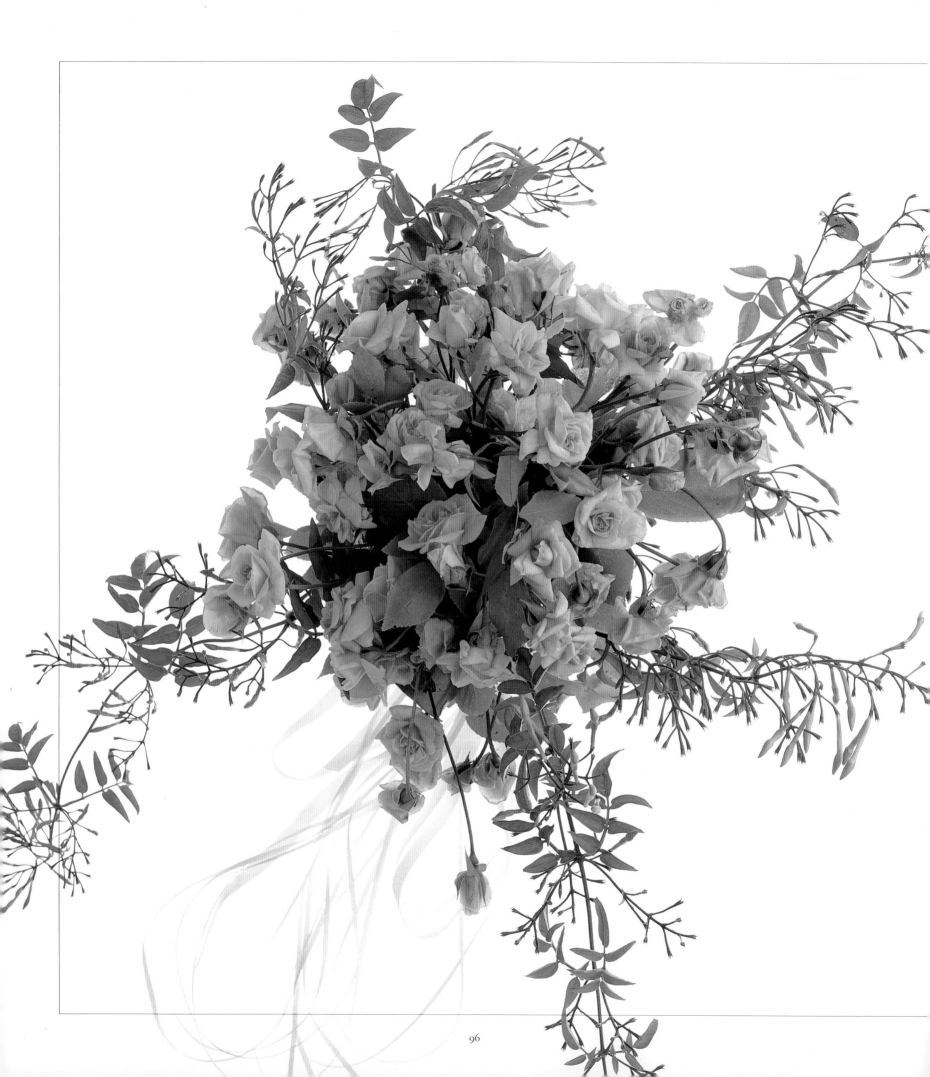

Flowers are magic.
The English wove garlands
of St. Johnswort,
sure protection against the
Devil himself.
Those who wore the garlands or
looked through them
at the midsummer bonfire
would be spared
headaches for the year.

In Victorian England, the language of love was flowers. Lady Wortley Montagu noted that lovers could send their missives back and forth, telling volumes, "without ever inking the fingers." Each flower conveyed an individual sentiment, of course, but the manner in which the flowers were arranged and delivered bespoke volumes as well. A flower inclined to the right meant the flower message was aimed at the recipient. Leaned to the left, flowers represented an admirable personal quality in the sender.

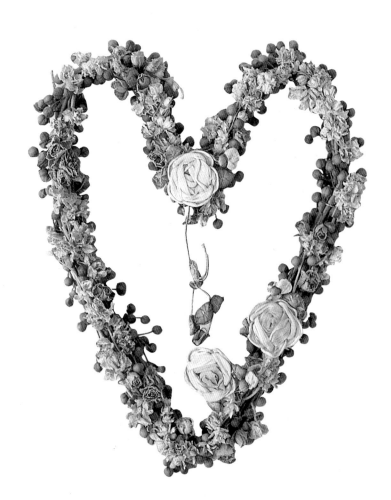

Cleopatra carpeted the floor with fresh roses for Mark Anthony.

Our bed dreams down the Nile

Under bright summer roses I cultivated for you.

"All my hurts / My garden spade can heal," wrote Emerson in Musketaquid. The essence of understanding flowers is to know that the herbalists and homeopaths, poets and romantics are right: Flowers may not cure everything, but they can spin a powerful spell. In country districts where people celebrate May Day, some still believe that a girl who rises at dawn, washes her face in the dew, and puts on a May Crown of flowers will marry the very first boy she meets that morning.

– – – – –

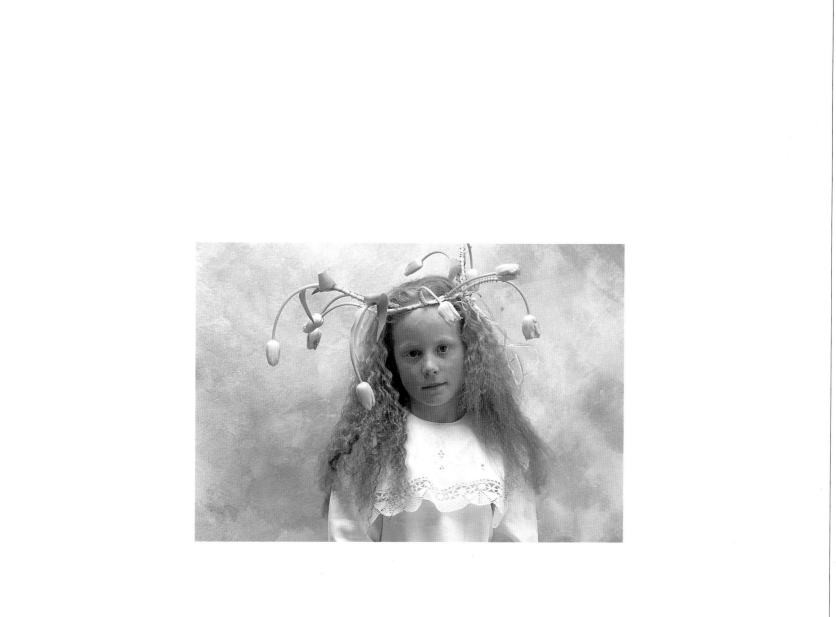

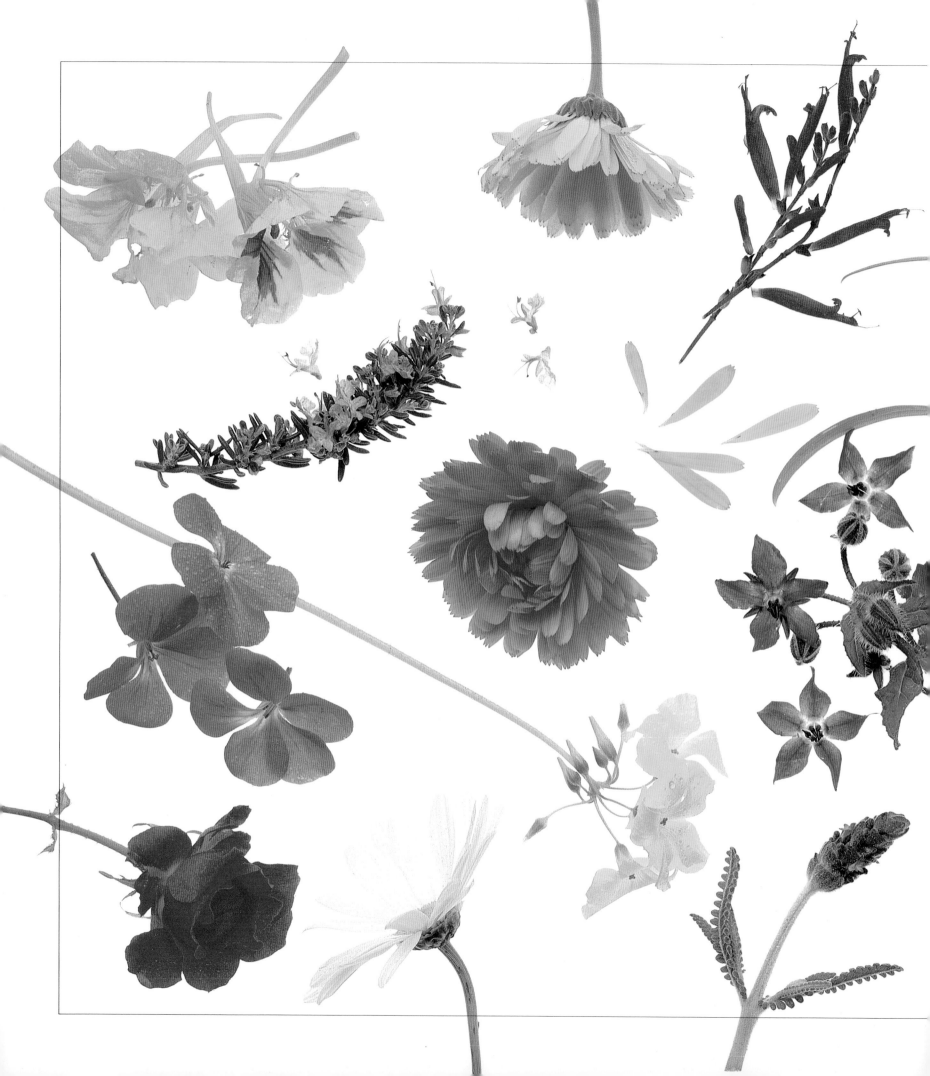

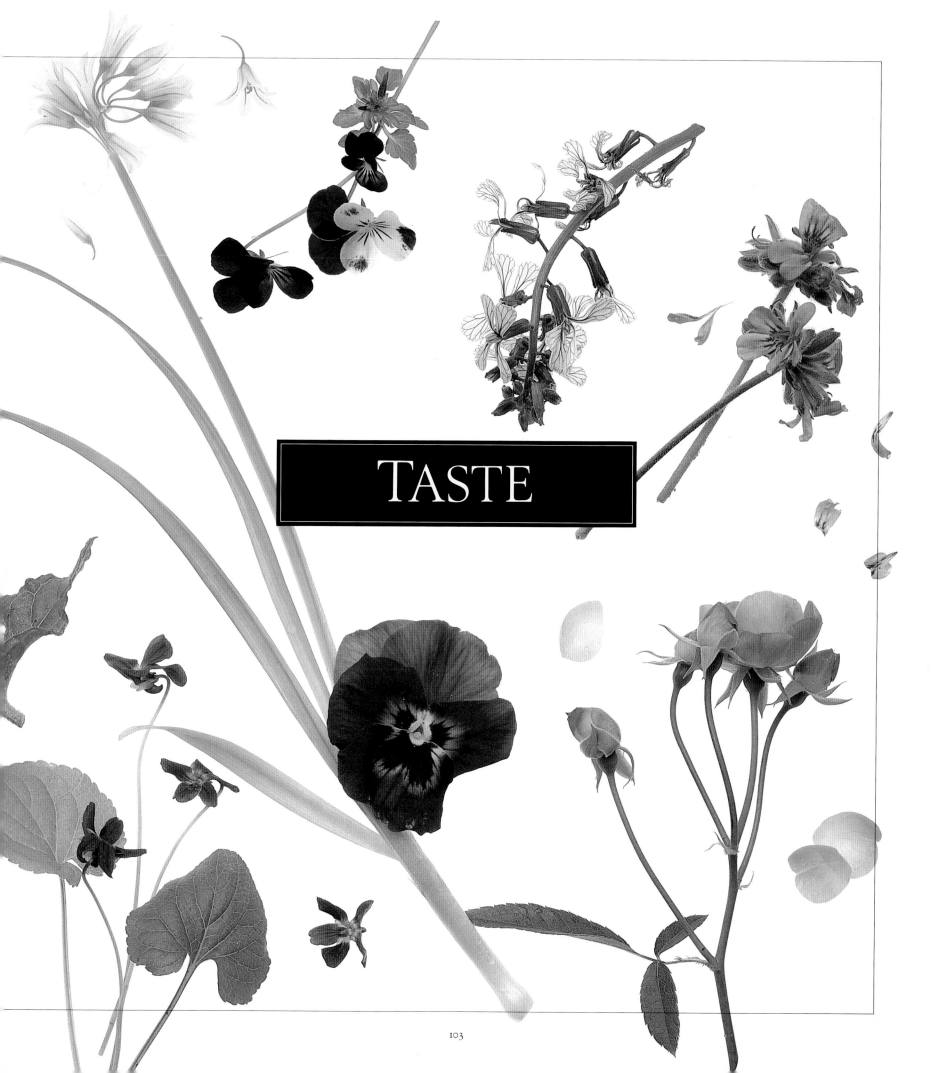

TASTE

Categories can be very misleading. Even those who should know better have sometimes imposed restrictive categories onto the garden: useful vegetable gardens over here and ornamental flower gardens over there. ¶ But Nature creates no such categories. Vegetable gardens are ornamental, to be sure—lacy carrot tops, baby lettuce shaped like pale green roses, artichokes rising complex and stately on sturdy stems. ¶ As to the usefulness of flower gardens, consider the recipes in the pages that follow. Not only do flowers and herbs serve as garnishes, but they are useful in the strictest sense of the word—they nourish body and soul. They are grace notes of color and taste. ¶ For the initiated, flowers can offer more than a visual feast; they can please the palate as well. This, we think, was Nature's intent. Unless they are tainted by pesticides or chemical fertilizers, many green and growing things on the earth are good to eat. There's the spicy taste of nasturtiums, the sweet oniony bite of chive blossoms, and the surprising cauliflower notes of chrysanthemum. Good cooks are accustomed to reaching for

PLEASE BE CAREFUL! All flowers used in food must be grown in pesticide-free environments. Do not use commercially grown flowers for cooking. If you have any doubt about whether or not a flower or herb is edible, please consult a botanical dictionary or a nursery. The names of the edible flowers pictured on the title pages of this chapter can be found in Sources, page 159.

herbs and spices, but creative cooks know that the flowers, as well as the leaves, add taste and beauty to food. Ignore the little glass bottles on your market shelf and look to the garden instead. Look for tiny snowy white flowers on savory stems, for sky blue rosemary blossoms, for the white or yellow flowers of mustard. ¶ The flower garden has been the country cook's extended kitchen for generations. In the England of King Charles II, court chefs pounded violets and chicory together to make a confection called violet plates. Shakespeare and his contemporaries ate rose petals in every variety from tea to jellies. Middle Eastern hosts traditionally serve delicious drinks after coffee, waters flavored with syrups made from mulberry, tamarind, or roses. ¶ These are recipes for those whose gardens spill onto the table, not just for ornament, but for the splendor of flowers in and on the menu.

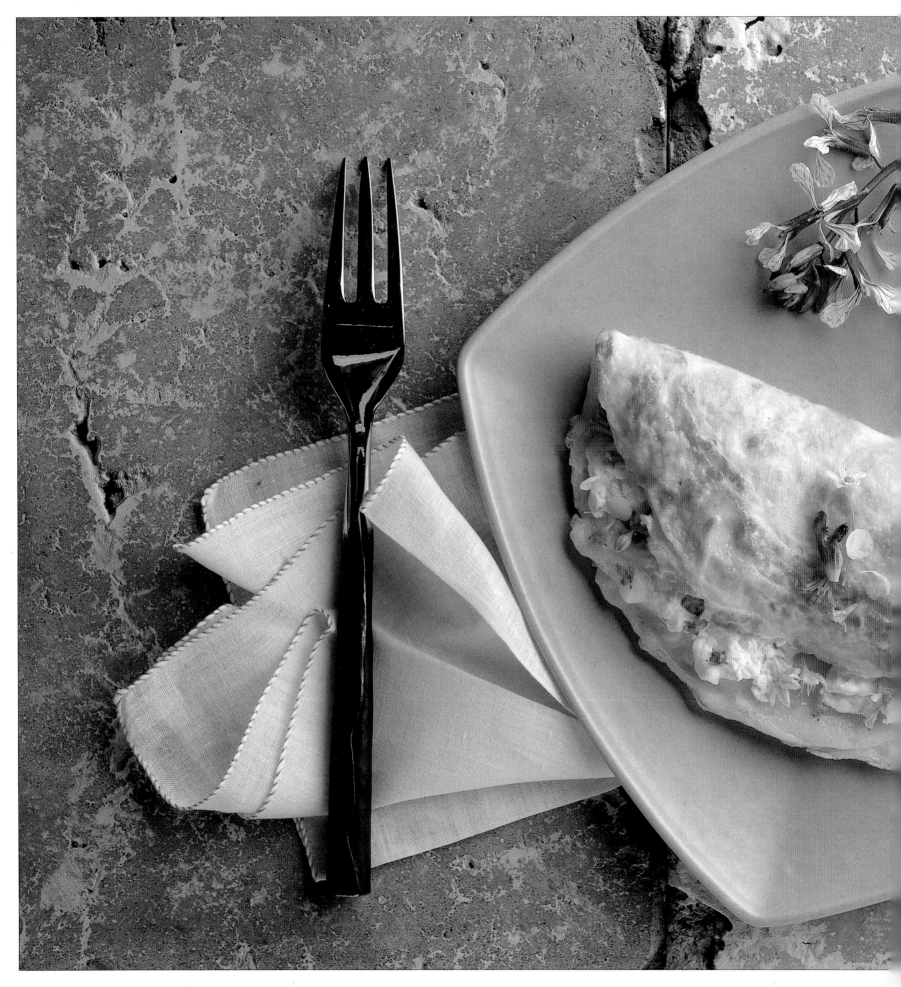

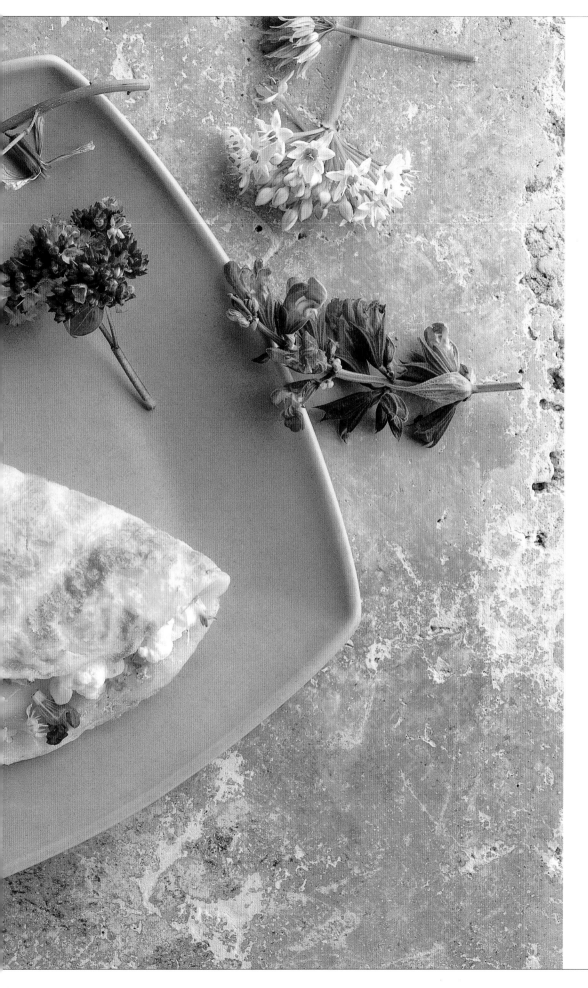

Herb Flower Omelet

Ingredients

- 2 eggs beaten with
- 2 tablespoons water
 Butter
- 3 to 4 tablespoons natural cream cheese
 Assorted herb flowers

Method

Melt enough butter for frying in
a 7-inch nonstick omelet pan over
medium heat. Add eggs. As they
set, pull in the edges to allow
any uncooked egg to run below.
When set, dot half the omelet
with cream cheese and most of the
herb flowers. Fold and slide
onto serving plate. Sprinkle with
a few additional flowers.

Herb flowers shown around plate:

arugula	*chives*
garlic chives	*oregano*
sage	

Herb flowers shown in omelet are:

garlic chives	*oregano*
sage	*mustard*
chives	

Scented Geranium Muffins

Ingredients

- 2 tablespoons butter, melted
- 1 egg, beaten
- ½ cup milk
- 1 cup unbleached white flour
- ¼ cup sugar
- Pinch salt
- 1 teaspoon baking powder
- ⅓ to ½ cup scented geranium blossoms

Method

Combine butter, egg, and milk. Whisk together dry ingredients and add to egg mixture. Stir in half of the blossoms. Pour into greased mini-muffin pans. Sprinkle remaining blossoms over top surface of muffins. Bake at 400 degrees for about 15 minutes, or until lightly browned.

Yield: approximately 20 muffins.

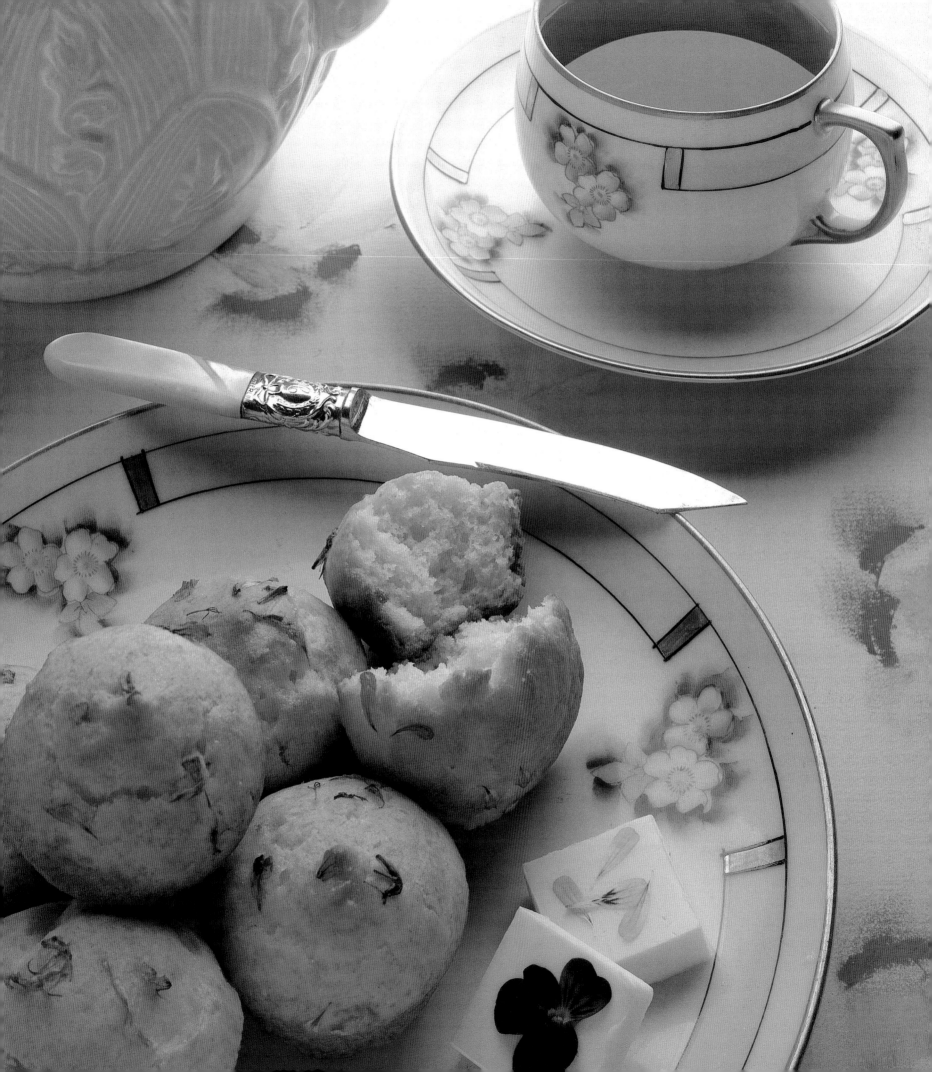

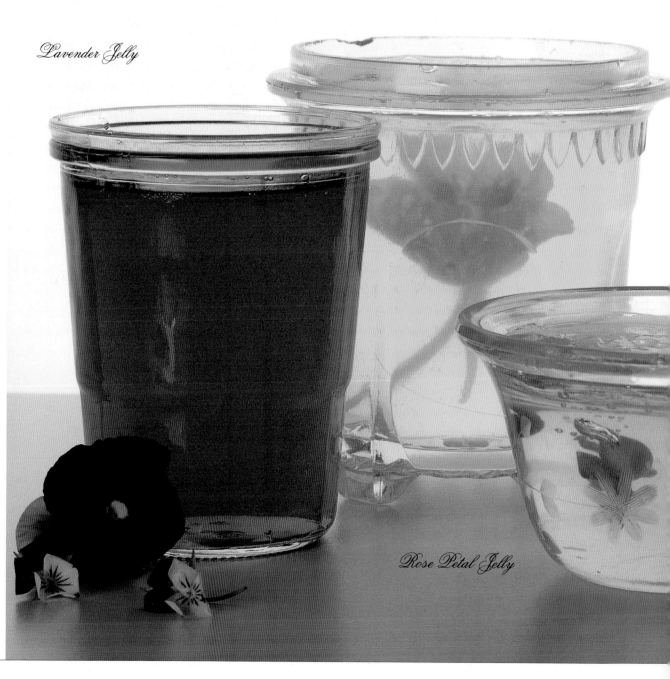

Michaele Thunen's
Flower Jellies

Nasturtium Jelly

Lavender Jelly

To make infusion cover 2
cups flowers with boiling water.
Cover container and keep
in darkness 24 hours. Strain
through three layers of cheese-
cloth and add the juice of half a
lemon. Measure the liquid in-
fusion; to every cup infusion
add two cups sugar. Bring entire
mixture to a boil and boil hard for
one minute. Add a package
of liquid pectin and return to full
boil for one minute. (Use a
larger pot as the mixture tends to
boil over.) Remove from heat
and allow to cool briefly before
pouring into sterile jelly jars.

When adding whole flowers to jelly,
allow jelly to cool but not set.
If it's too hot, the flower will cook;
if it's too cool the flowers can't
be inserted smoothly. Use bamboo
skewers to insert flowers.

Rose Petal Jelly

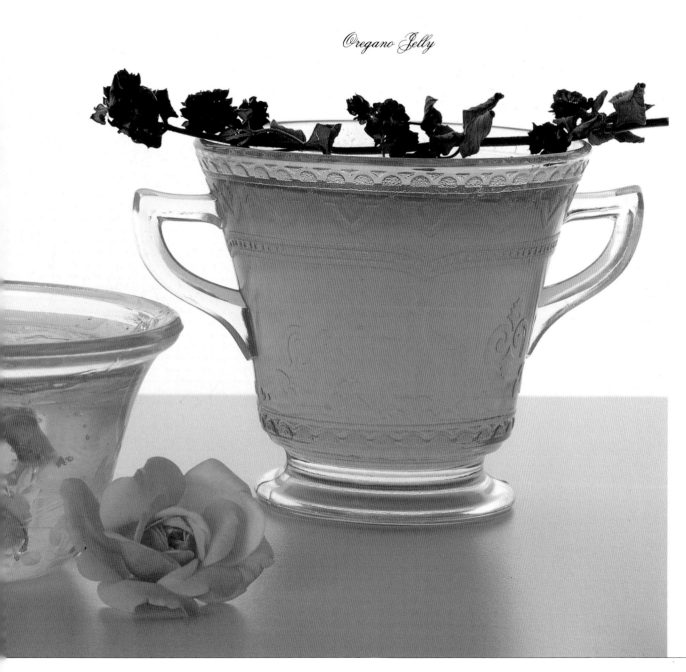

Oregano Jelly

Lavender jelly

Use two cups blue or purple
pansies or johnny-jump-ups for
coloring. Add a small infusion
of one teaspoon lavender for taste.

Nasturtium jelly

Use two cups nasturtiums. Add
an infusion of jalapeño pepper and
a dash of tabasco for taste.

Rose petal jelly

Use two cups rose petals for
coloring. Add two or three
drops of rose flower water (sold
in pharmacies) for taste.

Oregano jelly

Use two cups oregano blossoms
for both coloring and taste.
(Make sure to use blossoms,
not the leaves.)

Flower Petal Salad

Lettuces

endive

mâche

arugula

frisée

red oak leaf

limestone

red butter

radicchio

watercress

Flowers

pineapple sage blossoms

rose geranium

redwood sorrel blossoms

pansy

marigold petals

borage

rose petals

nasturtium

Raspberry Vinaigrette

Whisk together two parts

extra-virgin olive

oil with one part raspberry

vinegar. Add more vin-

egar to taste, as desired.

Dresses four servings.

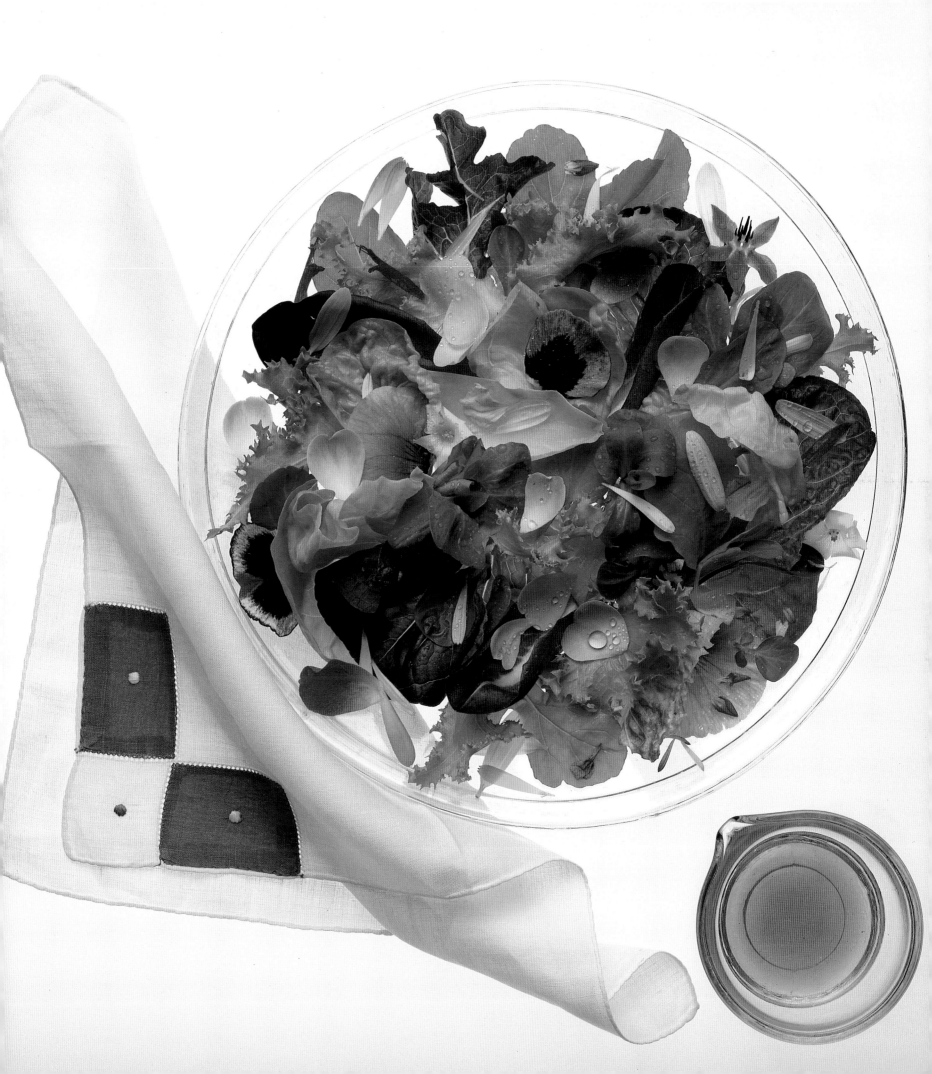

Nasturtium Pizza

Ingredients

For a 10 to 11-inch pizza:

1 Packaged pizza crust mix

¼ teaspoon blended Italian herbs

2 small or 1 large leek, cleaned,
 sliced thin, and sautéed in
 Rosemary-infused olive oil

½ small zucchini

½ small pattypan squash

½ small sunburst squash

3 ounces dry Monterey Jack cheese

½ ounce grated Parmesan cheese
 Handful nasturtium
 petals and blossoms

Method

*Prepare pizza crust as per package
directions for a 12-inch thin-
crust pizza, adding the Italian herbs
to the dry mixture. Shape dough
into a freeform round, 10-11 inches.
Bake on a parchment-lined bak-
ing sheet at 425 degrees on lowest
oven rack for 10 minutes.*

*Slice squashes very thin. Slice cheese
using a cheese plane. Top pizza
crust with leeks and the sliced Jack
cheese and squashes. Bake an-
other 5 to 7 minutes, until cheese melts.
Sprinkle with Parmesan and
bake a few more minutes, until
cheese melts. Sprinkle with nasturtiums.*

Yield: 1 to 2 servings.

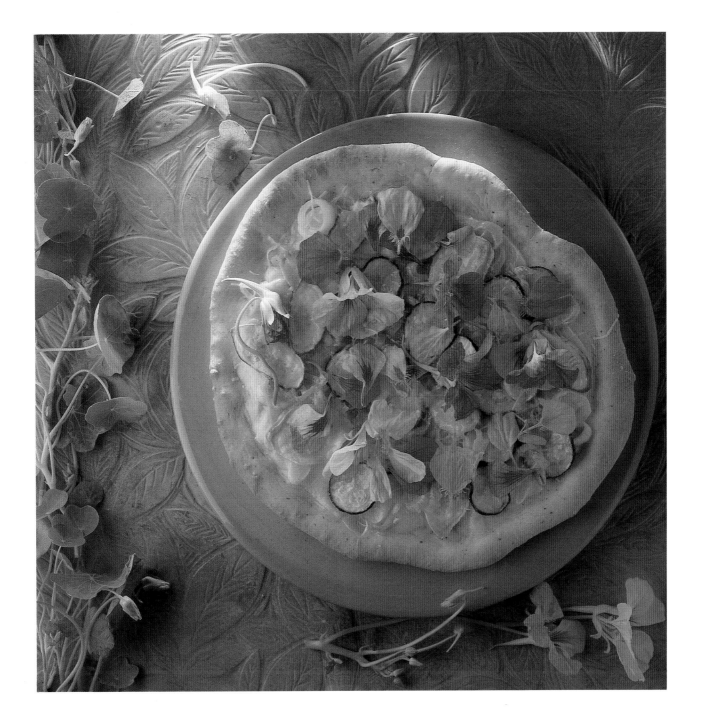

Honey-Lemon Sorbet

Ingredients

1 cup fresh lemon juice

1 cup water

⅓ to ½ cup honey, depending
 on sweetness desired

1 egg white, beaten until foamy

4 calla lilies

Method

*Combine lemon juice, water, and honey until
thoroughly blended. Stir in egg white. Freeze in ice
cream maker as per manufacturer's instructions.
Scoop onto waxed paper and freeze until serving time.
To serve, clean the lilies with damp toweling.
Remove the central spike from each flower. Place on
serving plates and fill with sorbet. Please note:
Calla lilies are not edible flowers.*

Yield: 4 servings.

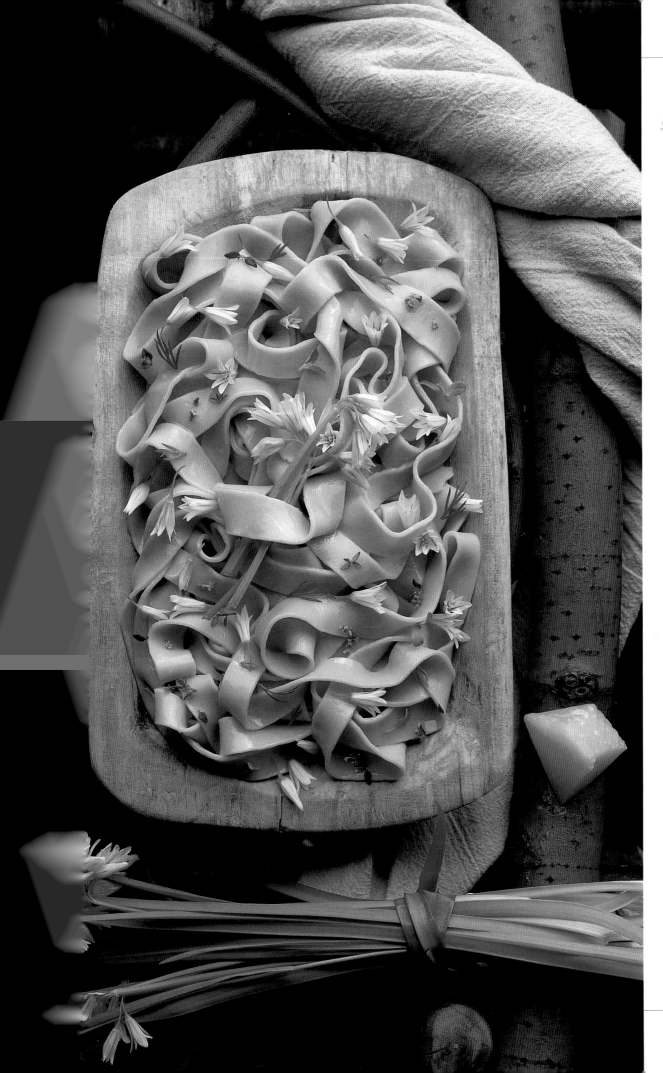

Pasta with Wild Onion Flowers

Ingredients

1 pound spinach fettucine
2 tablespoons unsalted butter
2 tablespoons olive oil
¼ cup assorted fresh herbs
 (thyme, oregano, marjoram, dill)
⅓ cup wild onion flowers
 Parmesan cheese, grated

Method

Prepare pasta as per package instructions. Rinse and drain. Melt butter in a large saucepan. Add oil. Toss pasta in butter mixture to coat. Gently toss in herbs and onion flowers. Serve hot, spinkled with grated Parmesan cheese.

Yield: 4 servings.

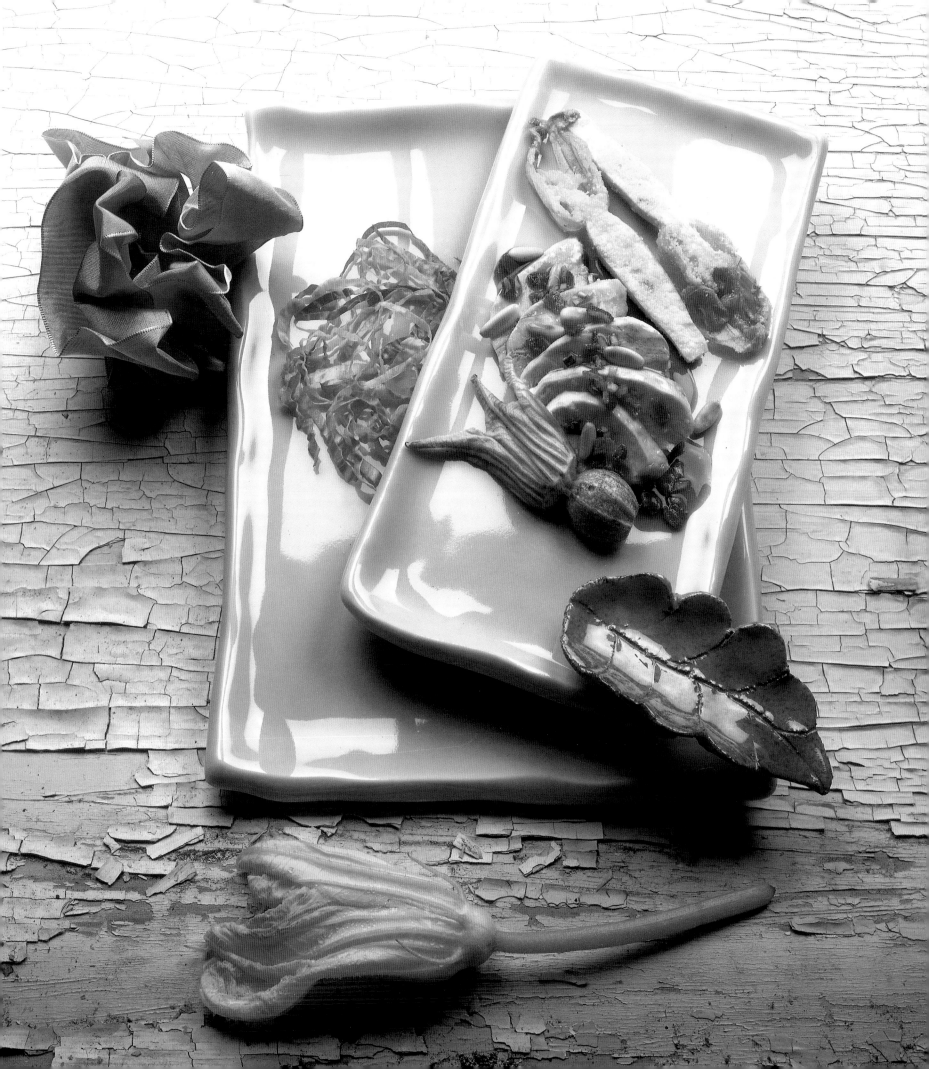

Ingredients

3 young zucchini, blossoms
 attached
¼ cup melted butter
 Cornmeal, for coating
2 tablespoons olive oil
2 chicken breast halves, boned,
 poached and sliced
1 slice bacon, cooked and crumbled
2 tablespoons pine nuts, toasted
2 large romaine leaves cut into
 fine strips

Dressing:

½ cup plus 2 tablespoons olive oil
⅓ cup balsamic vinegar
1 tablespoon minced shallot
1 teaspoon minced fresh marjoram

Method

*Slice zucchini in half lengthwise.
Dip, cut side down, in melted
butter and then in cornmeal. Heat
olive oil in a skillet over low heat
and fry zucchini, cut side down for
about 3 minutes, until lightly
browned. Remove from pan and
drain on paper toweling.*

*Combine dressing ingredients.
Warm over low heat. To serve, fan
one chicken breast on each
serving plate and surround with 3
zucchini halves. Sprinkle with
bacon and pine nuts, and drizzle
with some of the vinaigrette.
Serve romaine strips on the side.*

Yield: 2 servings.

Flower Canapés

Viola–brie pinwheels

Cut ready to roll pie pastry into 2-inch squares. Make 4 diagonal cuts, one from each point, toward but not into center. Form the pinwheel by folding alternating corner points into center. Press center firmly. Bake on parchment at 375 degrees about 7 minutes, until lightly browned. Remove from oven. Place a small slice of Brie in the center of each warm pinwheel. Transfer to serving platter. Place one viola on each pinwheel just before serving.

Shrimp paisleys

Using a cookie cutter, press out shapes of light rye bread. Press out identical shapes from ¼-inch thick slices of honeydew melon. Spread rye shapes with a little mayonnaise. Top with melon, a cooked bay shrimp, hyssop, and marigold petals. Serve cool.

Stuffed nasturtiums

Pipe herbed cream cheese into cleaned blossoms. Chill. These may be made ahead and kept refrigerated.

Cucumber cups with tobiko and marigolds

Using a lemon stripper, stripe a cucumber. Cut it into ½-inch slices. Use a melon baller to scoop out a hollow in each slice. Fill with cooked rice seasoned with vinegar and a little sugar. Top with Tobiko caviar, marigold petals, and a few black sesame seeds.

Rose petal finger sandwiches

Trim crusts from thin-sliced white bread. Spread with softened cream cheese and sprinkle with rose petals that have been cut into julienne strips. Cut bread slices into bars and stack to form two layers. Top each canapé with an inch piece of haricot vert (baby string bean) that has been blanched and split lengthwise.

Lavender–beef ovals

Cut a baguette into diagonal slices ¼-inch thick. Spread with softened butter blended with lavender blossoms. Top with cooled slices of rare beef and sprinkle with additional blossoms.

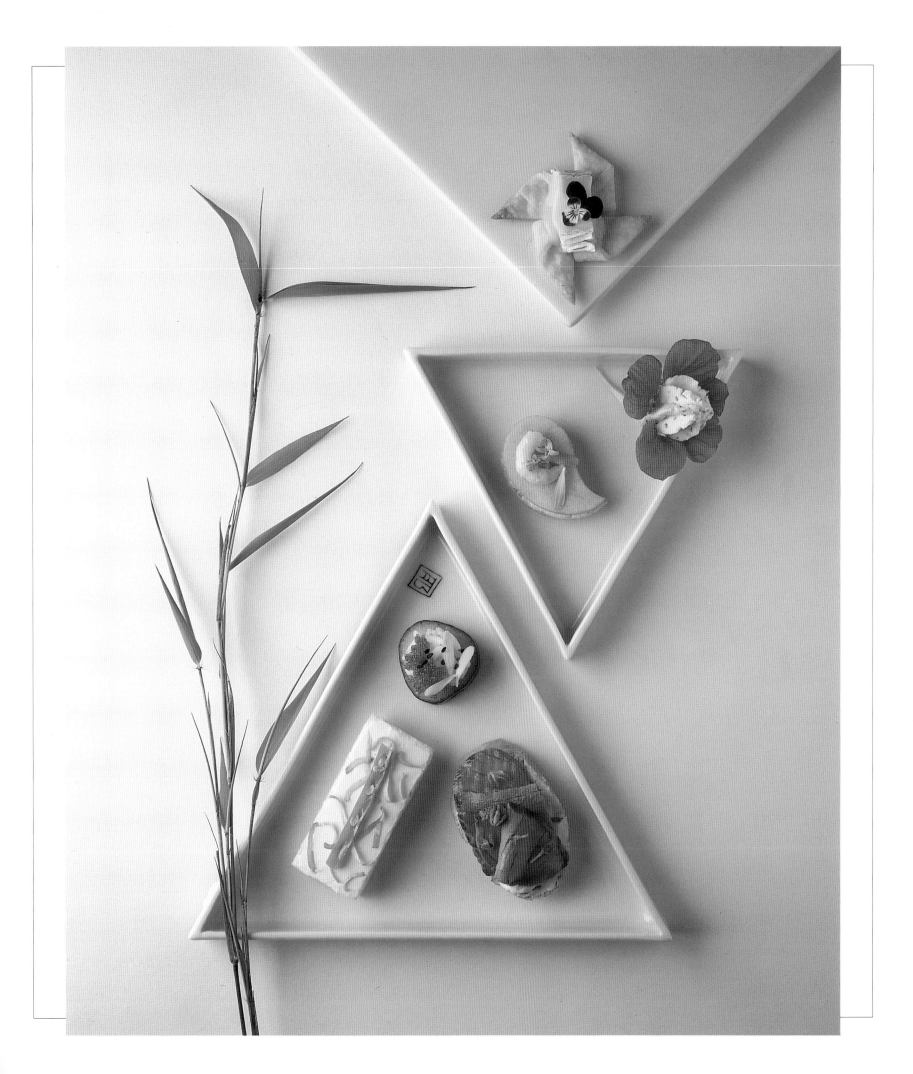

Vichyssoise with Violets

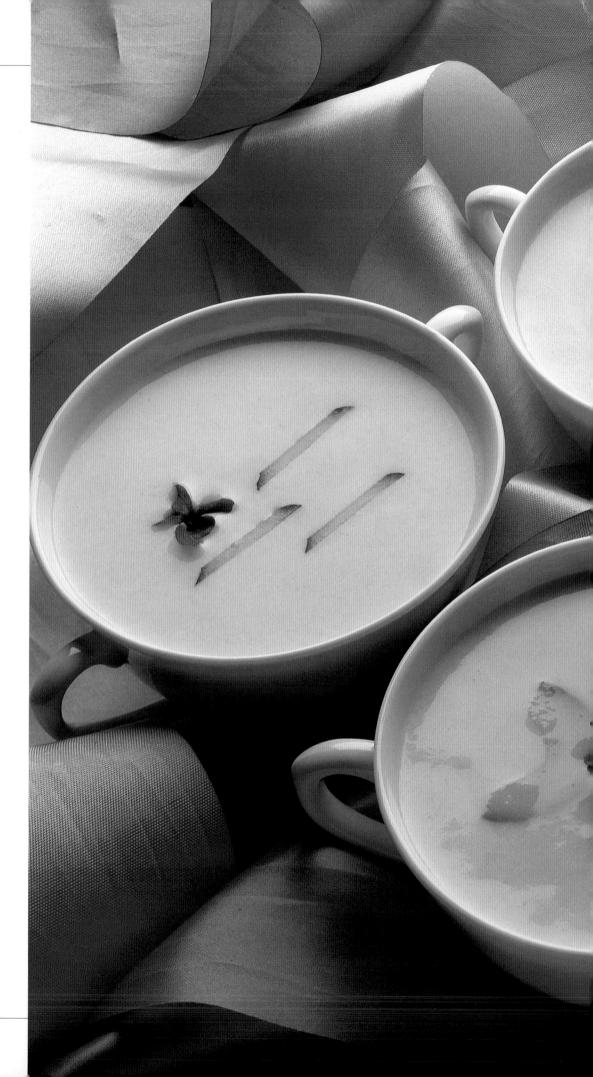

Ingredients

- 2 shallots, sliced
- 5 leeks, white and pale green portions, sliced thin
- 2 tablespoons unsalted butter
- 4 medium potatoes, peeled and sliced thin
- ¼ cup dry white wine
- 5 cups chicken broth
- 1 cup half & half
 Dash salt
 Dash white pepper
 Cucumber, sliced for garnish
 Violets for garnish

Method

In a large saucepan sauté shallots and leeks in the butter over low heat for 10 minutes. Add potatoes, wine and broth. Bring to a boil. Reduce to simmer. Cover and cook 25 minutes. Process in small batches in a food processor until smooth. Add half and half. Salt and pepper to taste and mix well. Chill. Serve cold in individual soup bowls. Garnish with various cucumber shapes. Float a violet on each serving.

Yield: 8 servings.

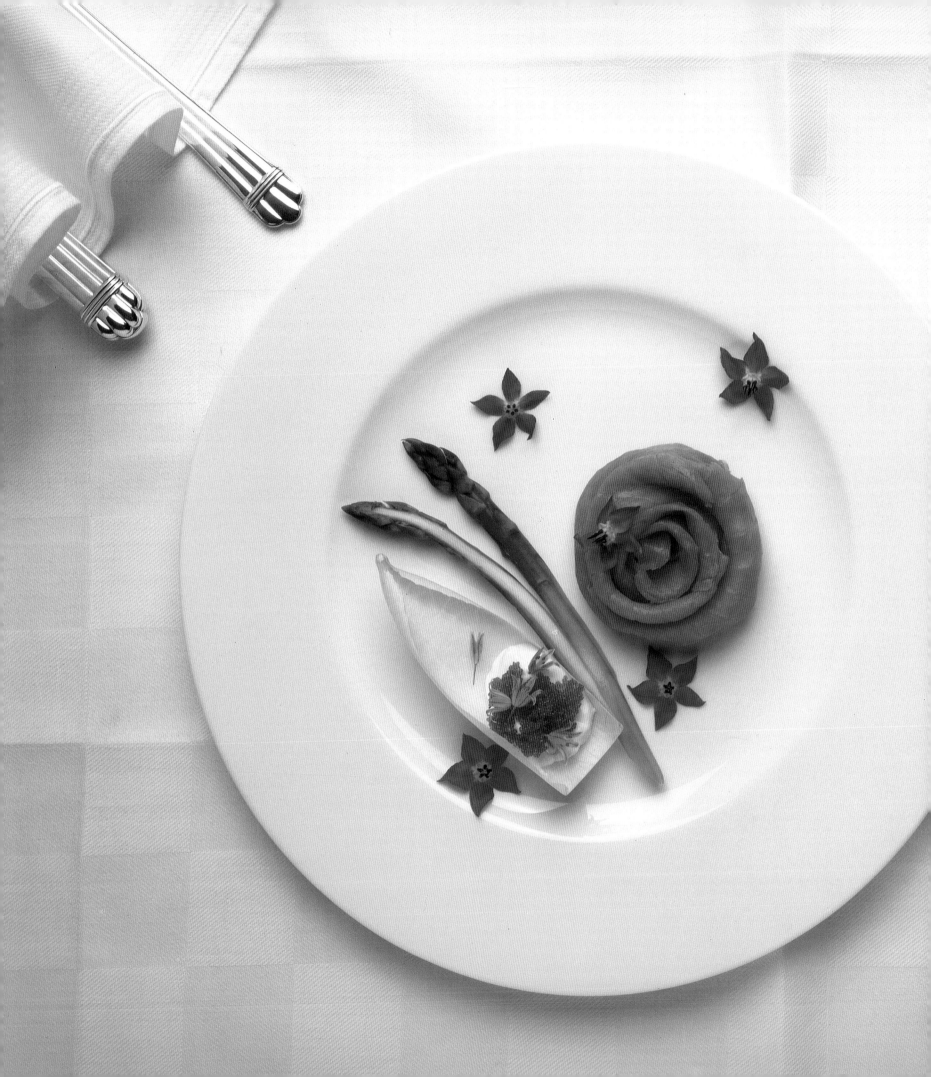

Smoked Salmon Plate

Ingredients

For each appetizer plate:

3 slices smoked salmon
1 asparagus spear, peeled,
 blanched, and split lengthwise
1 endive spear
 Dollop sour cream
 Dollop Tobiko caviar
 Chive blossoms
 Borage blossoms

Method

*Curl salmon slices around
one another to form a
rose. Fill endive spear with
sour cream, caviar, and
chive blossoms. Place sal-
mon rose, asparagus,
and endive on salad plate.
Sprinkle with borage
blossoms. Serve with honey-
dew dill sauce.*

Honeydew Dill Sauce

1 cup lowfat plain yogurt
½ cup honeydew melon purée
2 tablespoons fresh dill, snipped
 Mix all ingredients well.

Yield: 6 to 8 servings.

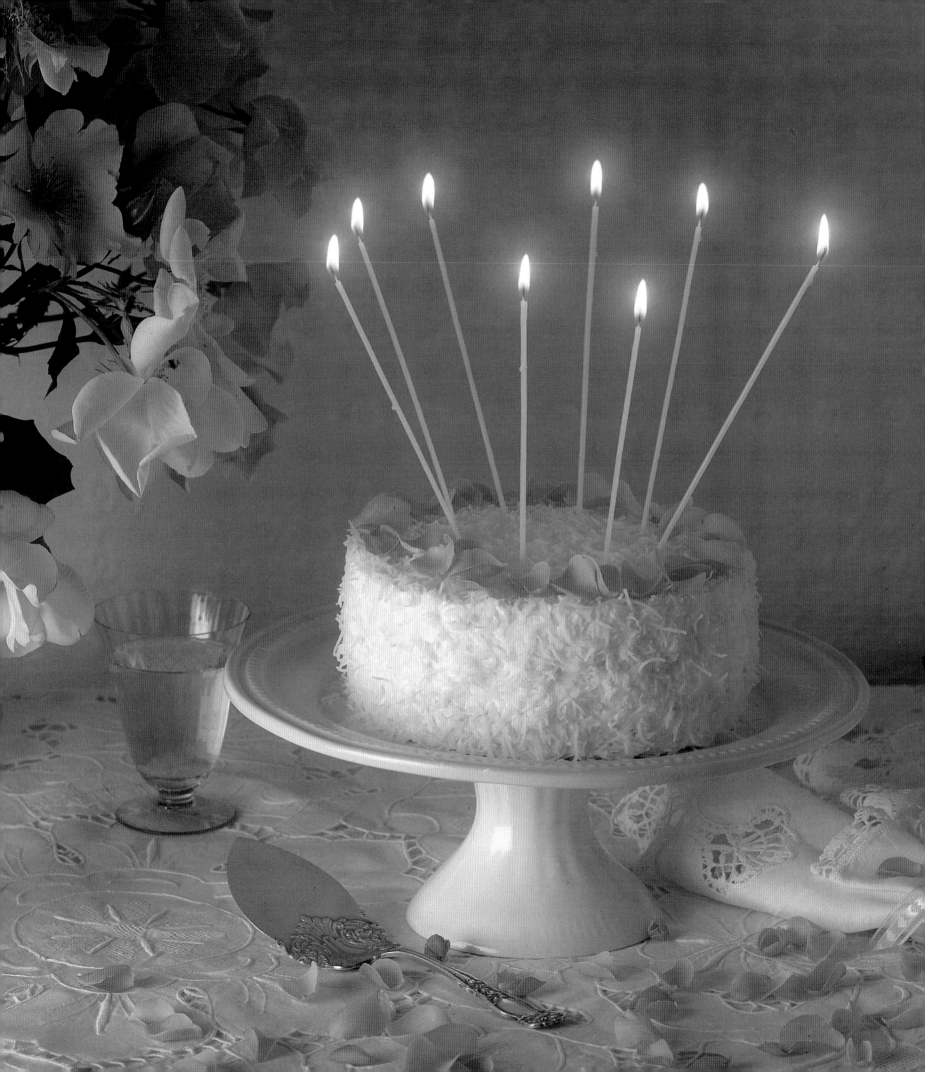

Special Occasion Cake

Fill the layer between a yellow or white cake with rose petal jelly and fresh fruit. Raspberries or thinly sliced strawberries work well. Frost cake with white icing; cover top and sides with shredded coconut. Border top surface with rose petals. Arrange extra-thin tapers in center.

Fine cuisine, creatively pre-
pared and beautifully
presented, delights the eye
as well as the palate. These
are the kinds of dishes that
would come out of Mother
Nature's kitchen, if it
were only she on the other
side of the swinging door.
Life is too short not to
take pleasure in every bite
of every meal; flowers in,
on, and with food enhance
that pleasure and help cre-
ate tables—and moments—
everyone remembers.

- - - - -

DREAMS

raume sind Schaume" (Dreams are froth), wrote Sigmund Freud. That was a common nineteenth-century belief until the Viennese master himself worked to persuade others that there was much to learn by studying what he called the Kingdom of the Illogical. Flowers grow wild and free in dreams; they have a place of honor in the Kingdom of the Illogical. ¶ These images don't pretend to psychoanalysis; instead, they are like dreams—fanciful, ephemeral, distinctly unreal. In the Kingdom of the Illogical, flowers dance, turn colors, wrap themselves around slippers, grow out of toys, and cling to the ceiling. ¶ We can only guess what flowers mean in dreams. Freud suggested they could symbolize innocence, because the Angel holds flowers in Renaissance paintings of the Annunciation, but offered too that they might symbolize the opposite of innocence. Consider the sensuality of *La dame aux camelias*. ¶ In dreams, flowers can be symbols of the

Nature provides a garden pharmacopoeia for insomniacs. Anise, dill in hot milk, ginseng, mandrake, marjoram, peppermint, primrose, and pillows stuffed with wormwood are all country cures for insomnia. As for ensuring peaceful slumber, history tells us that the Countess of Hainault sent rosemary to her daughter Philippa in England, after her marriage to Edward III in 1328. Court customs say that rosemary hidden under the bed delivered the sleeper from "all evil dreams."

erotic and the extravagant. Georgia O'Keeffe's lush flower paintings have been interpreted as the most explicit explorations of erotica in bloom. Dazzling in scale, these works invite entry into a world of dreams. "I'll paint it big," she wrote, "so they will be surprised into taking time to look at it. I will make even busy New Yorkers take time to see what I see of flowers." ¶ The soft yellow, orange, or white powder that dusts the inside of a flower is pollen, granular microspores produced in the anther chambers so that flowers can reproduce. In their dreams, romantics imagine instead that pollen is magic dust, an innocent pharmaceutical, guaranteed to fill velvet nights with images of wonder, mystery, intrigue, and beauty.

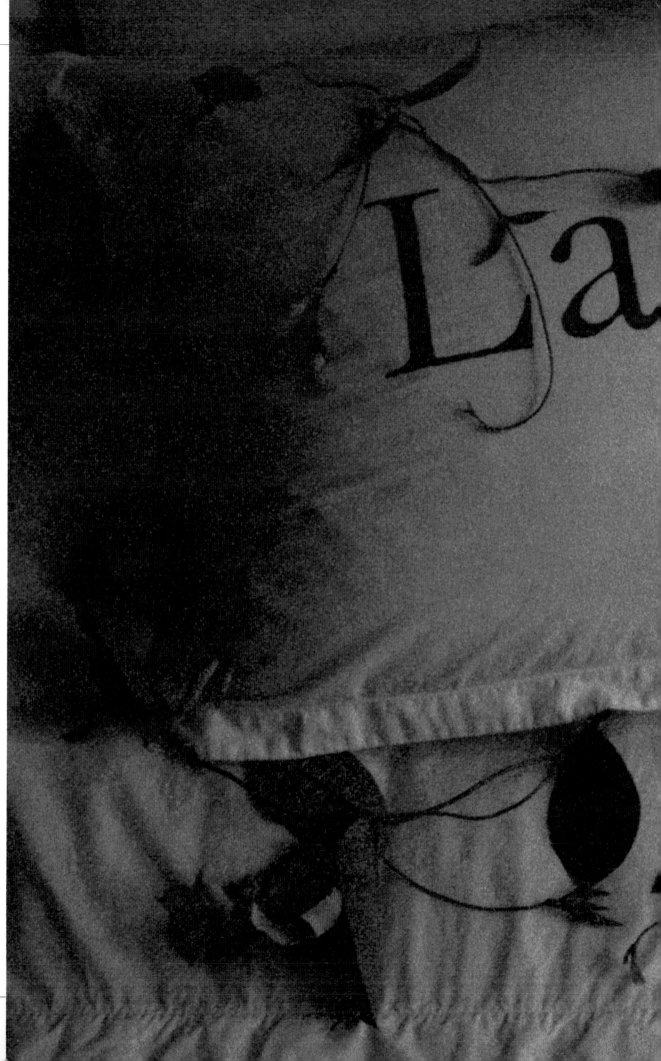

T here was a full moon in those days, it shone into the bare room and laid the pattern of the windows on the floor. I thought that the moon might be looking in and wondering how long I meant to stay on, in a place from which everything else had gone. 'Oh no,' said the moon, 'time means very little to me.'"

Isak Dinesen, *Out of Africa*

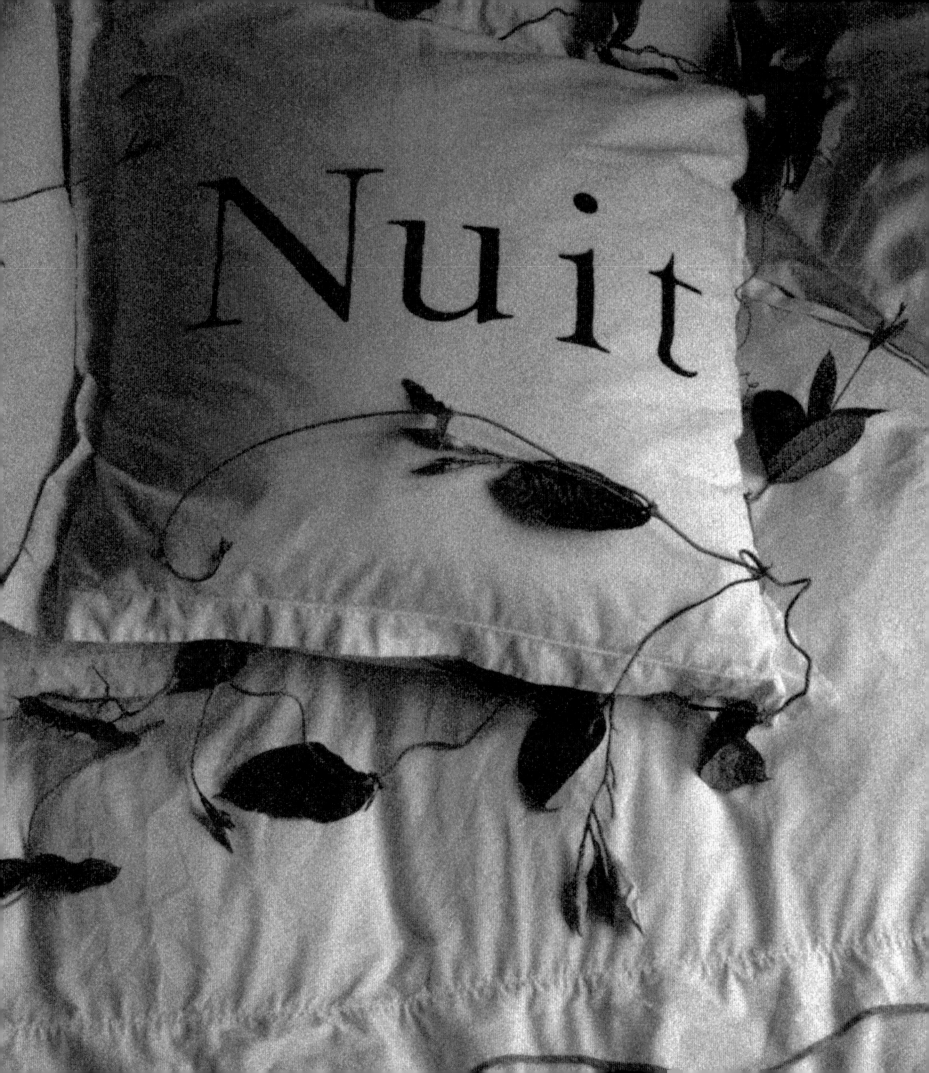

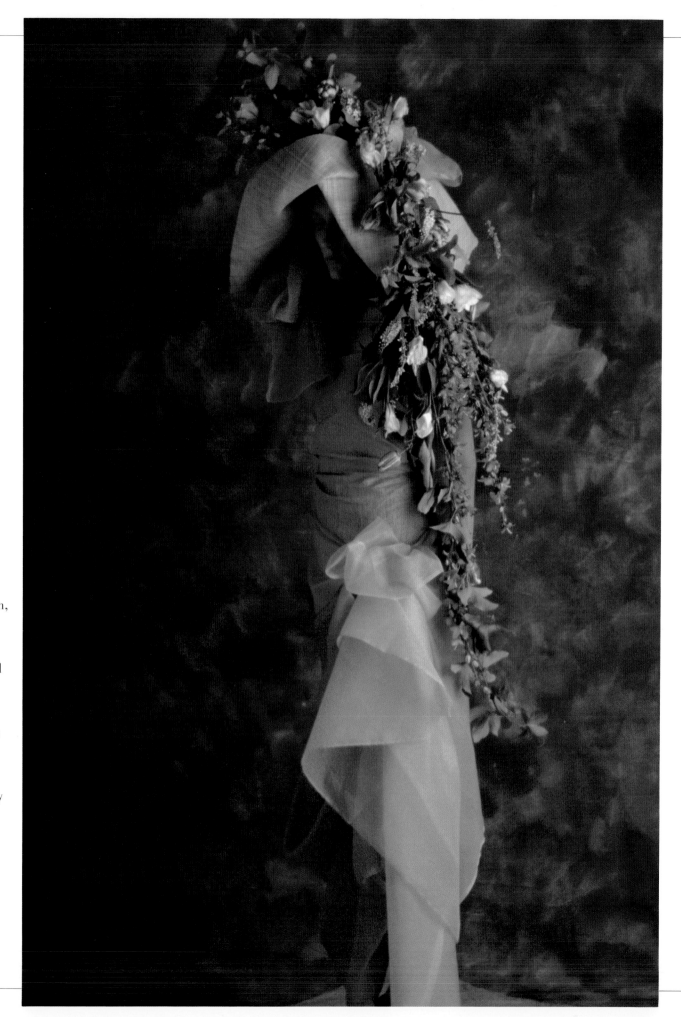

In ancient Mesopotamia, more than 2,500 years ago, a beautiful city stood on the banks of the Euphrates River. The city was Babylon, a name that meant "door of the gods." Though it had been destroyed once by the Assyrians, the city was rebuilt and came to be known as a center of luxury and sensual living. King Nebuchadnezzar ruled the city, and to please his wife and outshine the palaces of Assyria, he

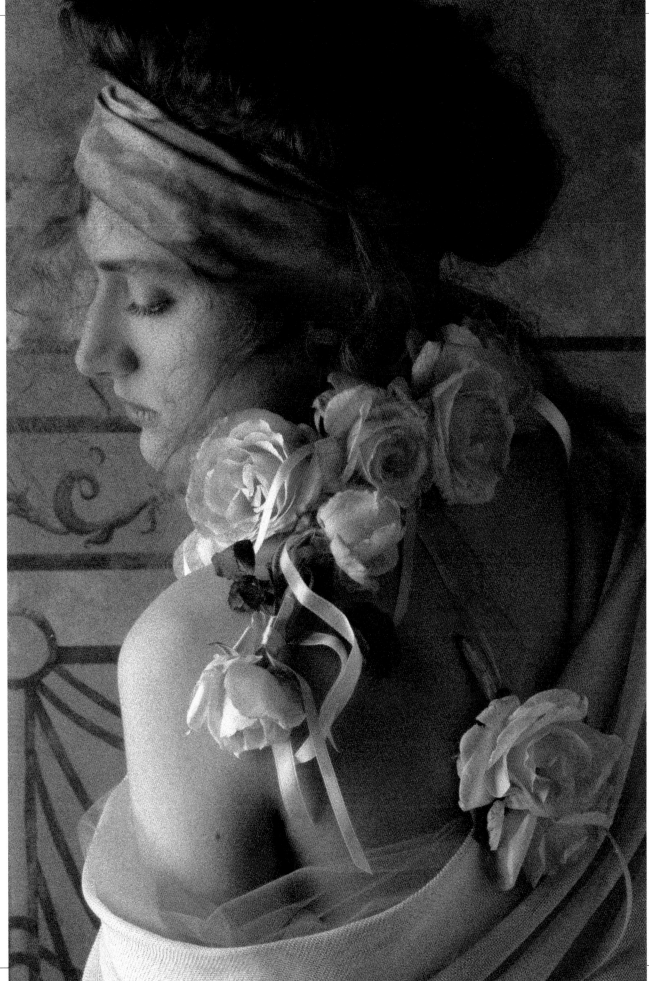

commissioned the design and construction of gardens beautiful beyond imagining. Stone terraces, some rising 300 feet into the air were built one on top of the other. In each terrace were gardens of tropical flowers, exotics, groves of fruit trees, and avenues of palm trees. Nebuchadnezzar's engineers designed an irrigation system to pump water from the Euphrates up to all the terrace levels. These were the Hanging Gardens of Babylon, one of the Seven Wonders of the Ancient World. They are gone now, but it's easy to believe that somewhere the young queen, homesick for the hilly town where she was born, still walks among fragrant groves, choosing flowers to wear to please her husband, the king.

I dreamed last night of the tropics

Of heavy, wet mornings

When early heat shimmered sleep away.

I remember a bowl of anthurium you left me —

Spiky red and yellow, shadows on the wall.

I shivered in my sleep, and wished for the sun.

There was the Black Dahlia, a puzzling murder that rocked Los Angeles in the 1930s. And then there was Brenda Starr's mysterious sweetheart, the man in the eyepatch who left black orchids on the pillow when he came to call. Finally, we developed a dozen midnight roses—smoky images that arrived almost of their own accord.

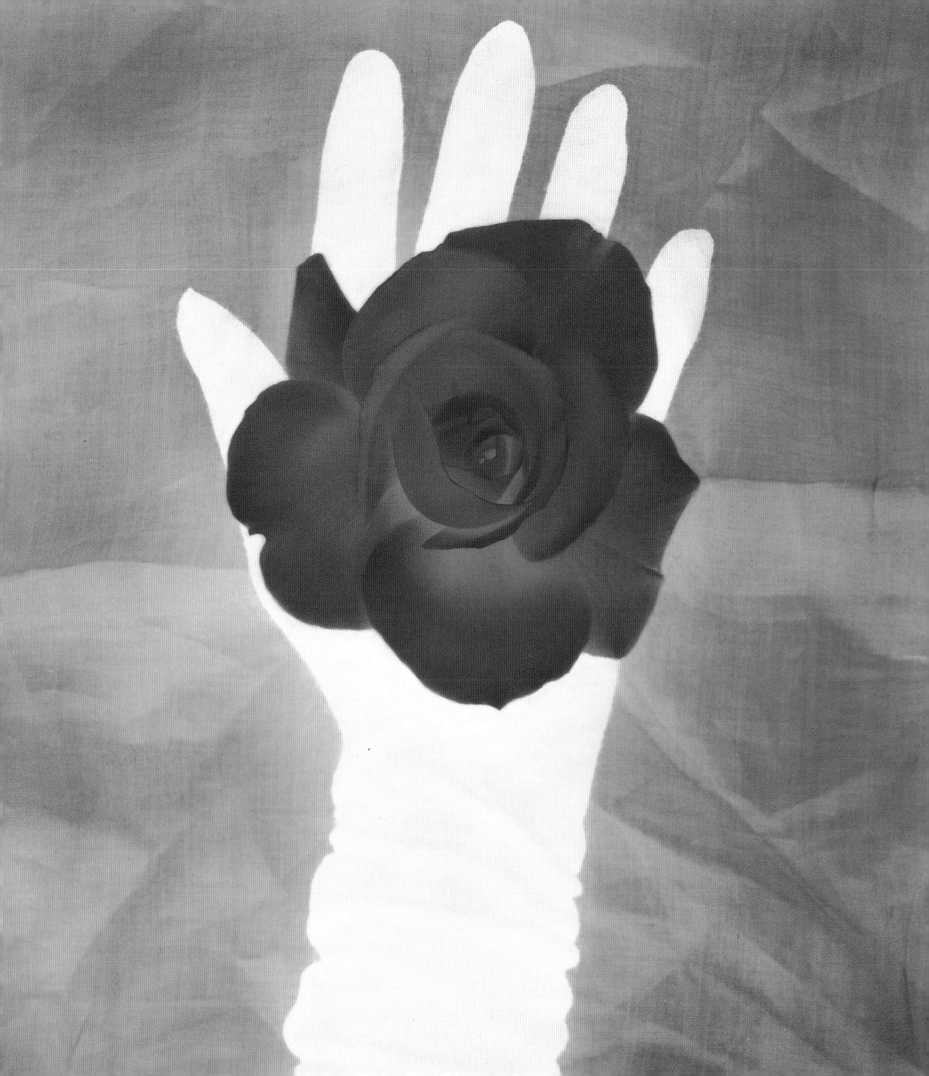

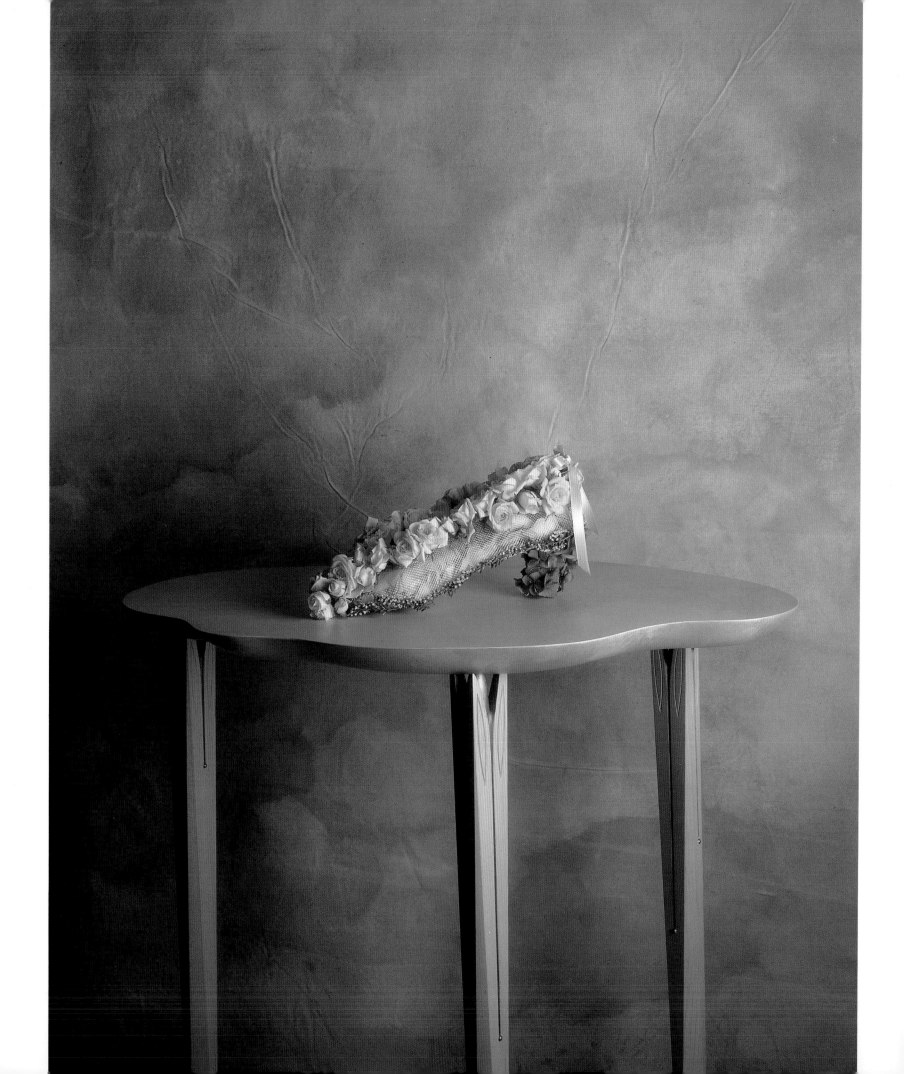

MY HOMAGE TO COLETTE: YOU SAW A WOODEN SHOE, A BIRD, A SILVER PLANT. WE COULDN'T BE THERE, SO WE DREAMED OUR OWN SHOE, OUR OWN BLOOMS. THE BIRD FLEW AWAY.

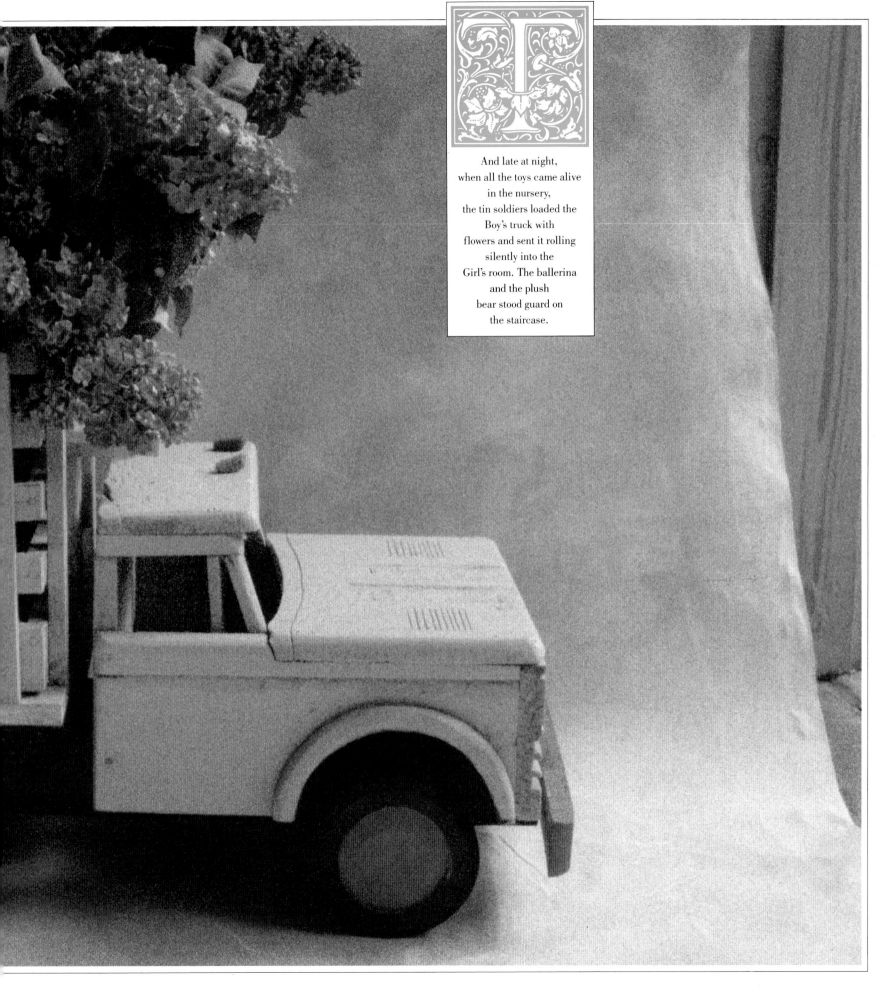

And late at night,
when all the toys came alive
in the nursery,
the tin soldiers loaded the
Boy's truck with
flowers and sent it rolling
silently into the
Girl's room. The ballerina
and the plush
bear stood guard on
the staircase.

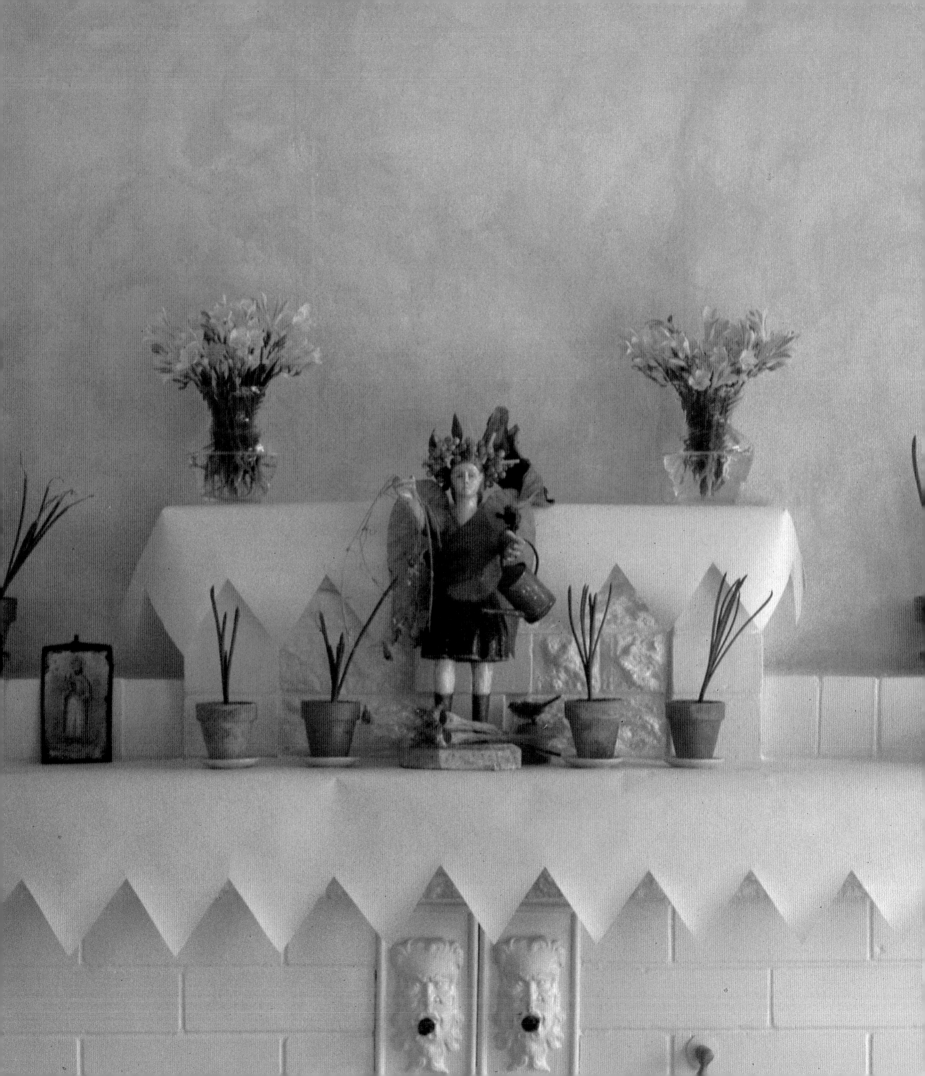

Creating Altar Images

Here are some tools for a classical education in religion: the Torah, the New Testament, the Koran, the Bhagavad Gita, the Book of Kells, the Book of the Dead, the Vedas. ¶ But in our dreams, the sacred takes shape in less literary form. Those stories merge and we cannot quite remember whether Ishtar was the daughter of the sky and the moon, or the sun and the stars. And is it true St. Peter dropped his keys when he learned people were approaching Heaven through the back gate instead of the front gate? And when those keys fell to earth, did they really take root and turn into cowslips? ¶ Imagine a backdrop for these stories, an altar of plain, white stone. Imagine music, strange and not quite harmonic. And because Eden was a garden, there must be flowers. New bulbs, just starting out. Fresh flowers, in full, showy, passionate bloom. And some mysterious figure, some caretaker who watches over this garden and all within its gates. ¶ When spring comes, it is best to believe in something. Despite the carelessness of the ordinary caretakers among us, narcissus, tulips, lilies still bloom. In our dreams, spring is the heady fragrance that stirs the air around the altar.

REGINALD FARRER

A passion for gardening can lead anywhere. Farrer was born in 1880 in West Yorkshire, the son of Anglican parents. At 14, he built a rock-garden in an abandoned quarry, and made his first contribution to the *Journal of Botany*. Farrer's interest in flowers—and disinterest in his father's occupation, politics—led him far afield. He became a Buddhist, and traveled in Japan, Korea and China. He hiked the Alps, the mountains between Kansu and Tibet and the Burmese frontier, looking for exotic plants. By his death in 1920, he had completed a remarkable collection of books and reportage. He wrote "...a fanaticism for beauty has always been the real key of my life and all its happinesses and hindrances."

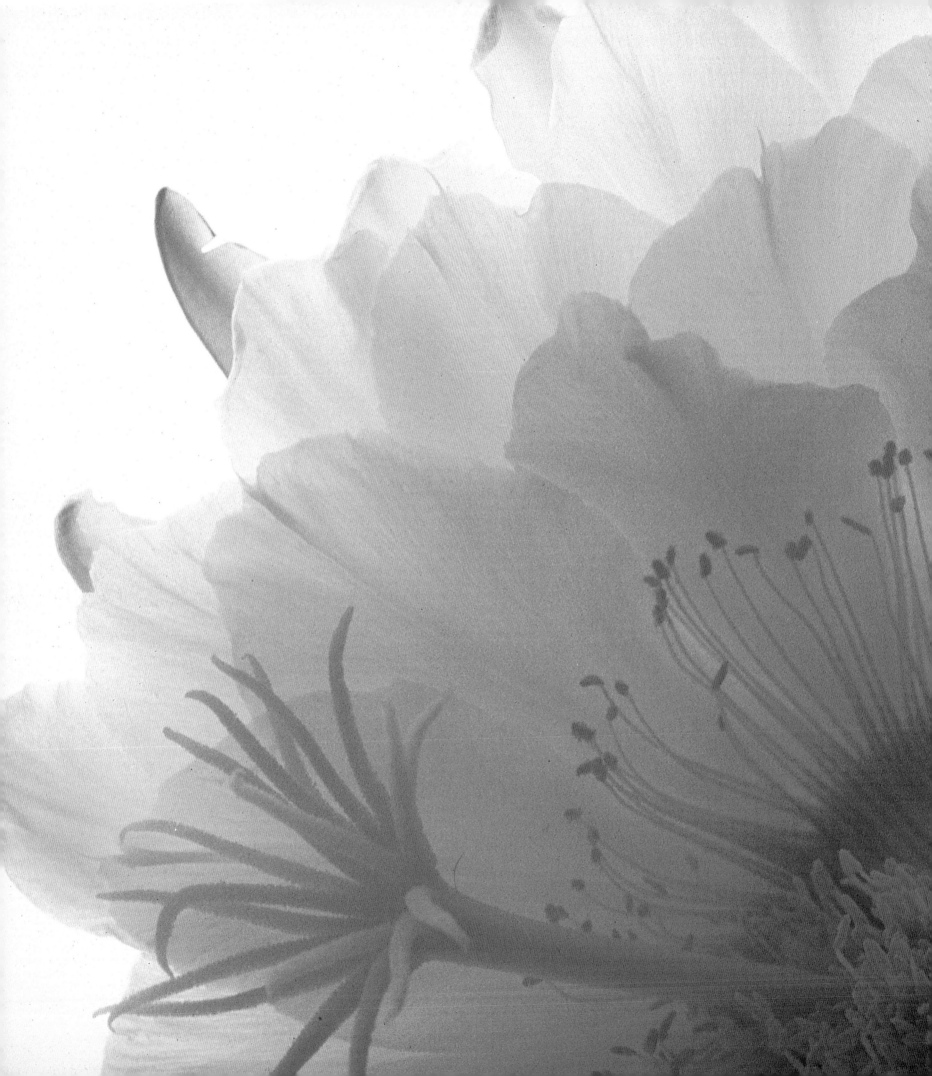

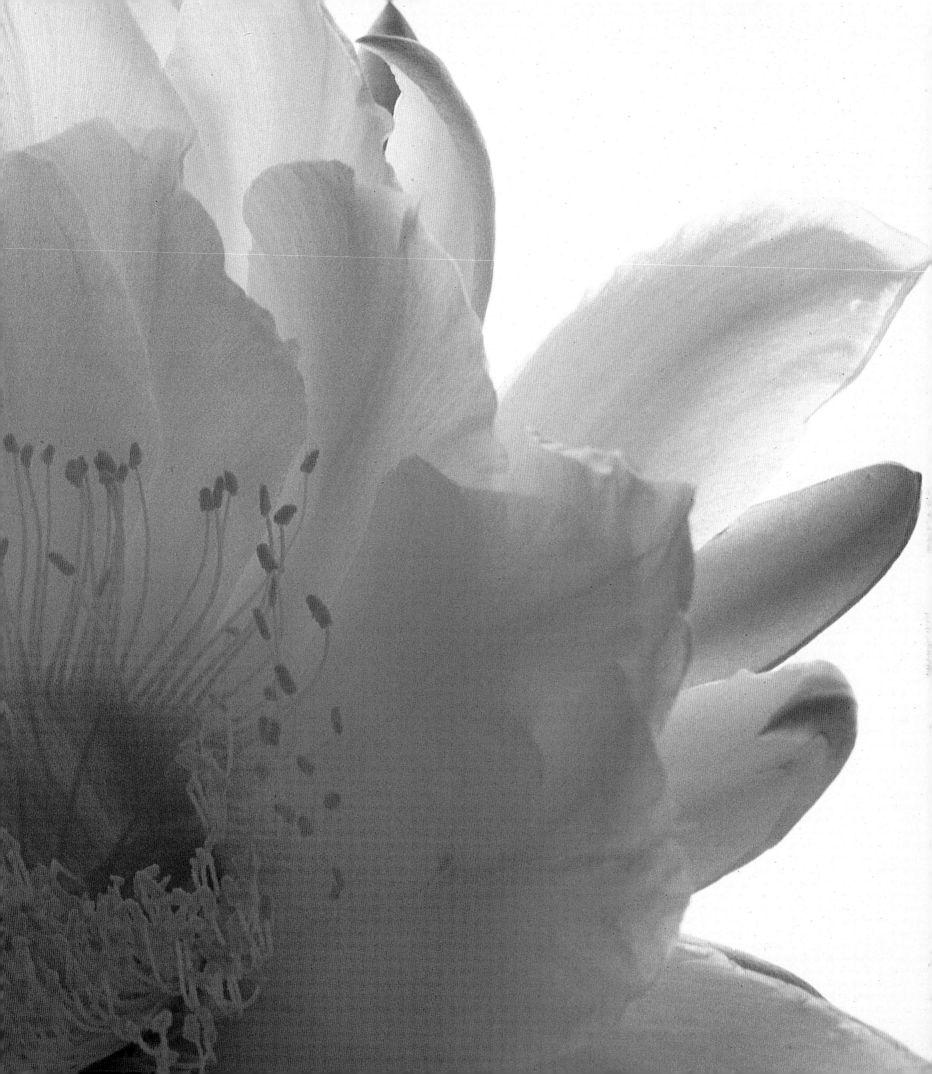

rocus. Solomon knew; crocus were his

allies. He was a king who raised to a

princely art, the practice of making love.

To his beloved he said: "Thy plants are an

orchard of pomegranates, camphire and

spikenard; spikenard and saffron." The

crocus family includes plants of sacrifice —

the Greeks spread them on bridal beds;

farmers must harvest 4,320 flowers to make

one ounce of saffron. But individually,

bright, striped, rich, and secretive, they

yield their beauty to a patient eye.

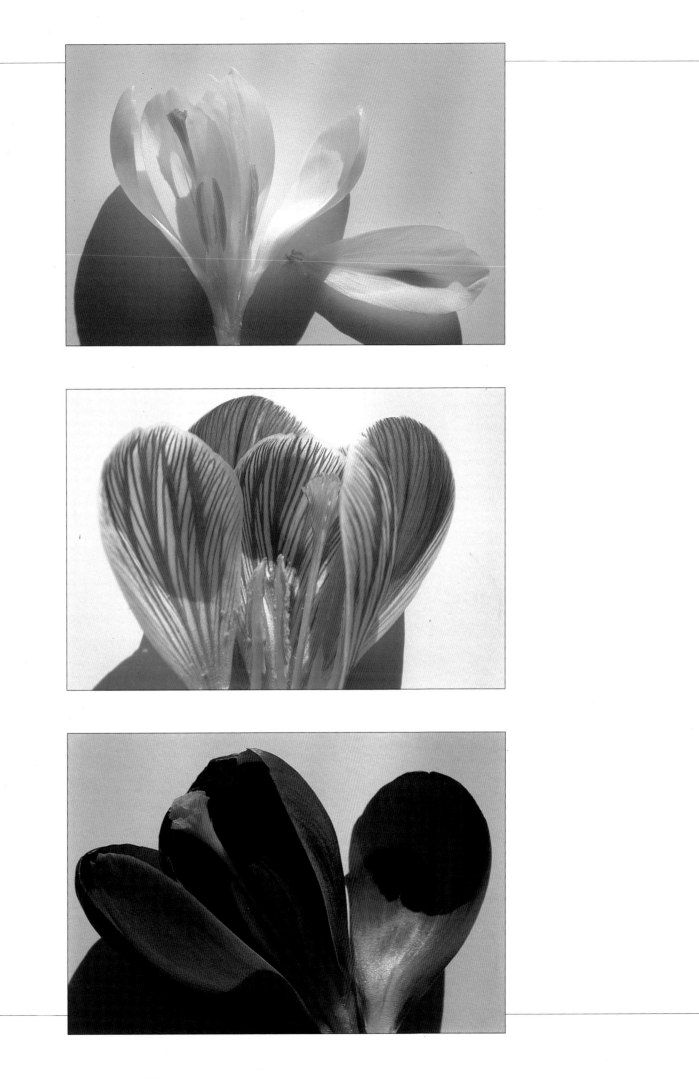

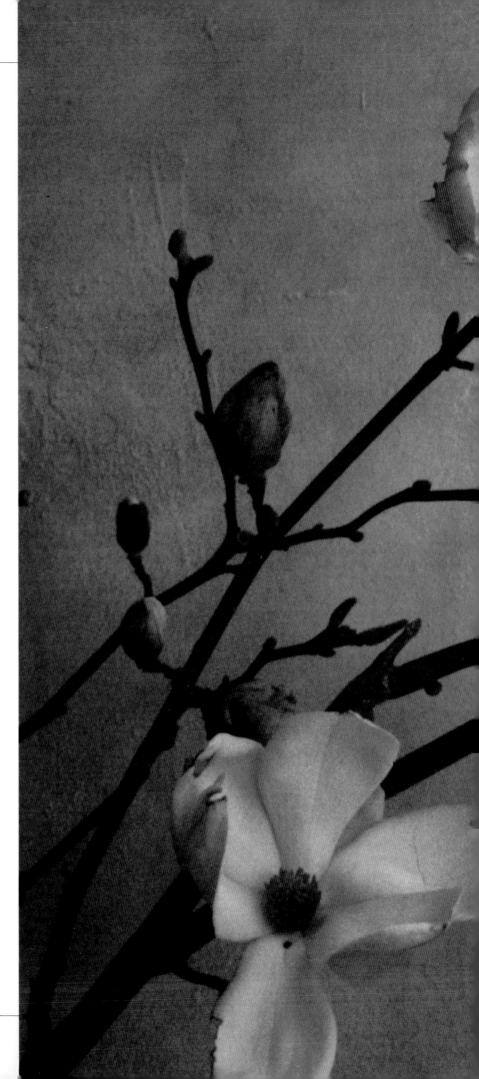

Everything Grows in My Mother's Garden

Everything grows in
my mother's garden:
Camellias, delicate pinks
and whites, splendid scarlets,
Graceful lilies, regal iris,
cheerful ranunculus.

Good things to eat grow in
my mother's garden.
Tomatoes as sweet as fruit,
peppers red and green,
Carrots, sugar peas, baby
lettuce.

'Coleslaw grows in my Nena's
garden.'
That's what my son brags to
his friends.
A city child, he thinks magic
transforms garden treats into
his favorite dish.

It is magic, I tell him,
Nena's magic. Her grace
with all things green and
growing.
There must be special secrets
in my mother's garden.

All of us, family and friends,
We marvel at my mother's
garden,
She must know secrets,
we think.

And, she does—
Secrets of generosity,
kindness, compassion,
Of life lived honestly,
imaginatively, well.

Still trim in gardening
clothes,
She brushes dirt and leaves
from her hands
And comes to greet us.

There's much I wish I learned
from my mother:
French seams,
Southern chicken, patience,
painting, some medicine.
For these things I have
no aptitude.

But now, a mother myself, I
crave a secret or two.
I want to garden, as she does
With grace and love
and skill.

We ordered bulbs together
this summer. She claims to
envy me my tulips. And I?
I want only this,
My son to say one day:

Everything grows in my
mother's garden.

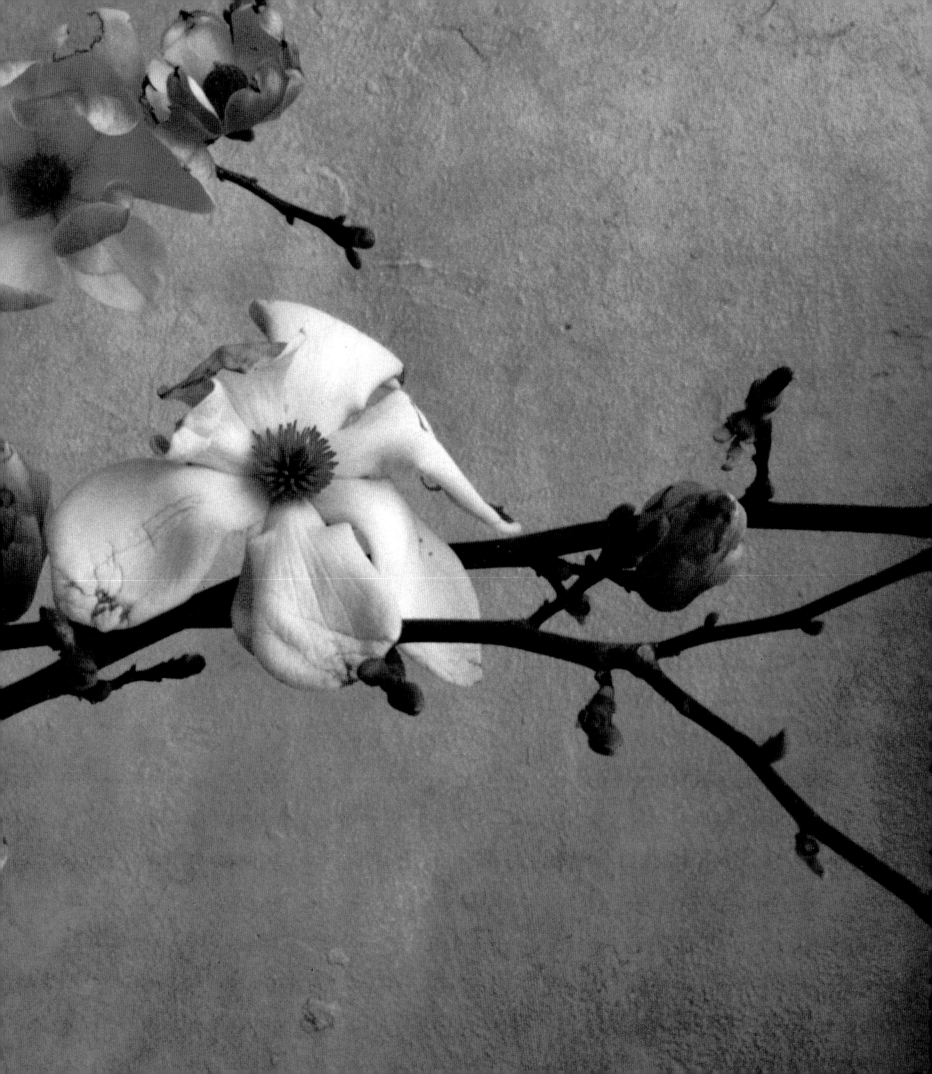

Gardens and secrets do seem to go together. There was a famous collection of clandestine erotica in the Victorian era called "My Secret Garden." Pyramus and Thisbe, those thwarted lovers, kissed through a chink in the garden wall. And Romeo stood heartsick in the garden under Juliet's balcony.

But the most magical of secret gardens may have been the one Frances Hodgson Burnett created for her young heroine—neglected, cranky Mary Lennox. *The Secret Garden* tells Mary's story, about her discovery of a "sweet, mysterious" place shut up for ten years. Together with two friends, Mary learns to make the garden beautiful again. Mary blooms, along with the garden, and grows into a kinder girl. Two things cannot grow in one place, she learns: "Where you tend a rose, a thistle cannot grow."

"The moon has ascended
between us
Between two pines
That bow to each other

Love with the moon
has ascended
Has fed on our solitary
stems

And we are now shadows
That cling to each other
But kiss the air only."

Christopher Okigbo,
Lament of the Lavender Mist

The Song
of the Windflower Fairy

"While human-folk slumber
The fairies espy
Stars without number
Sprinkling the sky.

The Winter's long sleeping,
Like night-time is done;
But day-stars are leaping
To welcome the sun."

In that instant, just before
sleep, when your dreams take
shape, may they grow like
a garden. Perhaps we'll
never return to Eden, but in
our dreams the gate stands
open and the air is fresh and
sweet with possibilities.
Remember the garden—and
dream new dreams.

- - - - -

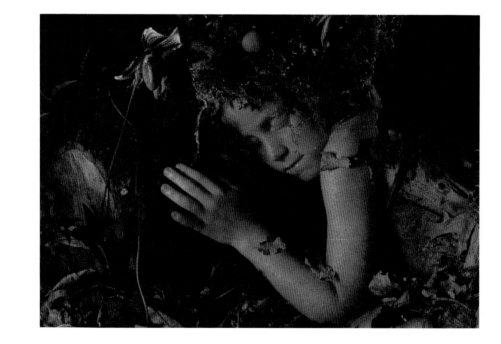

 Sources

Nasturtium
Calendula
Rosemary
Calendula
Pineapple sage
Wild onion
Viola
Arugula
Borage
Rose
geranium
TASTE
Rose
Impatiens
Daisy
Pansy
Rose
Redwood
sorrel
Lavender
Violets